A 3-D TOUR
OF LATTER-DAY
SAINT HISTORY

A 3-D TOUR OF LATTER-DAY SAINT HISTORY

BRINGING B. H. ROBERTS BACK TO LIFE

Steven L. Richardson and
Benjamin M. Richardson, editors

SIGNATURE BOOKS | 2017 | SALT LAKE CITY

FIRST EDITION | 2017

LIBRARY OF CONGRESS CATALOGING-IN-PUBLICATION DATA

Names: Roberts, B. H. (Brigham Henry), 1857–1933, author. | Richardson, Steven L., editor. | Richardson, Benjamin M., editor.

Title: A 3-D tour of Latter-day Saint history : bringing B. H. Roberts back to life / Steven L. Richardson and Benjamin M. Richardson, editors.

Other titles: Latter-day Saints' tour from Palmyra, New York, to Salt Lake City, through the stereoscope

Description: Salt Lake City : Signature Books, 2017. | New edition of B. H. Roberts's Latter-day Saints' tour from Palmyra, New York, to Salt Lake City, through the stereoscope, with 3-D glasses so readers can view the stereoscope cards.

Identifiers: LCCN 2017041150 | ISBN 9781560852674

Subjects: LCSH: Church of Jesus Christ of Latter-day Saints—History—Pictorial works. | Stereoscopic views. | LCGFT: Illustrated works.

Classification: LCC BX8611 .R7 2017 | DDC 289.309--dc23 LC record available at https://lccn.loc.gov/2017041150

CONTENTS

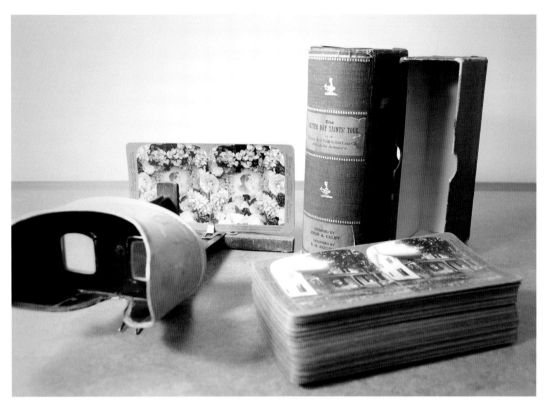

An unpacked 1904 edition of *The Latter-day Saints' Tour* at the LDS Church History Library, showing the slip-case box, thirty-eight stereographs, a stereoscope, and a portrait of Joseph Smith mounted in the device.

Stereoscopic viewing was a popular form of home entertainment in the early twentieth century. A stereoscope had two lenses and a card holder, the cards (stereographs) having two photographs of each scene taken from slightly different points of view. The lenses directed each eye's view toward a different image, creating a three-dimensional effect. .

In this edition we have combined (1) the stereographs created in 1904 by Henry Strohmeyer and marketed as a boxed set by Underwood and Underwood of New York with (2) a booklet the publisher commissioned, written by Brigham H. Roberts, giving historical context for each image. The project was the brainchild of John Califf of Carthage, Illinois.

The booklet was a 132-page pamphlet titled *The Latter-day Saints' Tour from Palmyra, New York, to Salt Lake City*. It was printed in the same dimensions (7 x 3½") as the stereographs. Other collections of 3-D images of the day were presented as tours, including the *Paris Exposition Tour*, *President Roosevelt Tour*, and *Real Children in Many Lands Tour*, as examples. People spent hours studying the photographs and thinking about the descriptions, feeling like they had experienced a verisimilitude of a real visit.

Packaged together in a cardboard box covered in fabric and enclosed in a slipcase that looked like a book, the word stereographs usually stamped on the spine, the cards and booklet were accompanied by a stereoscope, although often sold separately. The theme of the tour was evident from the booklet and from what was printed in the margins of the cards: the title of the set of images, the publisher's name, and a short caption.

Where Califf engaged Roberts to write descriptions of the images, we have turned that around and started with the text, to which we have added the images. In doing so, we have changed the format from three-inch-wide black-and-white photos to full-page duotones, visible with 3-D glasses rather than a stereoscope.

INTRODUCTION

As the poet Carl Sandburg explained, "When we look through the stereoscope we see what we would see if our head and eyes had been located in the exact niche occupied by the camera when the exposure was made of the photographic plate. That moment lives for us and becomes part of our lives as we range in thought and feeling over the surface presented to us in the two little prints mounted on cardboard distant a few inches."[1] Despite the advantage that three-dimensional viewing offers, by the 1940s stereoscopes had fallen out of favor as a source of home entertainment and education, and were replaced by magazines and radios, eventually by televisions and other electronic wonders. Stereoscopes, and the pictures themselves called stereographs, became antiques. Interest in the things that could be seen and learned by viewing old "anaglyphs" did not return until the mid-1970s after millions of the cards had been thrown away.

Artists have been painting in two dimensions since prehistoric times, but artwork in three dimensions was limited to sculpture. Nobody had really considered why human eyes could see nearby objects in three dimensions. In 1832 a British scientist, Charles Wheatstone, made simple geometric drawings from slightly different viewpoints. He then devised a simple device using mirrors by which anyone could view these images. He announced his

discovery (fig. 1) in 1838, the year before photography was invented by Louis Daguerre of France. For the next two decades photographs were limited to one-of-a-kind daguerreotypes, images etched by light onto a silver-coated sheet of copper. Since the metallic images were highly reflective and positive or negative, depending on the an-

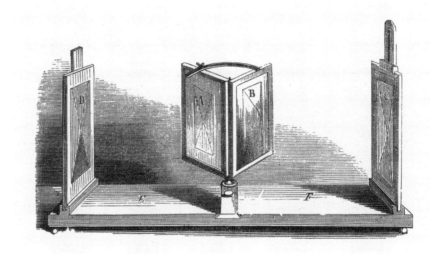

figure 1. Wheatstone stereoscope

gle of the light, they were unsuitable for viewing through Wheatstone's instrument.

In 1849 David Brewster, a Scottish scientist, devised a viewer that used lenses and a door controlling the direction of the light source (fig. 2), and he exhibited his invention at the World's Fair in London in 1851. There it caught the attention of Queen Victoria, and through her the devices became popular all over the world. However, Brewster's

1. Carl Sandburg, "Stereograph Poems," in *A Trip around the World through the Telebinocular*, ed. Burton Holmes (Meadville, PA: Keystone View Company, 1930), 76.

stereoscope was expensive and beyond the reach of most people. Eventually other less costly photographic processes were developed. For stereo images, photographic prints were mounted side-by-side on cardboard, usually measuring 7 x 3½ inches. A person's eyes are only about 2½ inches apart, but prismatic lenses diverted the view slightly outward and made it possible to view larger images whose centers were separated by three inches. An additional half inch on each side of the card was provided for handling the stereograph.

The next development came from an American, Oliver Wendell Holmes, who in 1861 invented an inexpensive stereoscope that could be purchased by the average person. Recognizing its value for education, he opted not to patent the device, making it a gift to the world. Joseph L. Bates manufactured a refined version that became the most popular model for eighty years (fig. 3). Stereoscopes of this kind were at the height of their popularity when the views featured in this book were published.

Most local photographic studios had cameras with two lenses for 3-D portraits and for photographing local scenery and celebrations (fig. 4). This was true in Utah, as well as elsewhere. For instance, the LDS Church History Library scanned about 1,000 glass-plate negatives created by pioneer photographer Charles W. Carter, and the library has placed them online, 37 percent of which were originally made as stereographs.[2] Other stereo photographers in early Utah included Charles E. Johnson[3] and Charles R. Savage,[4] who created small batches of the stereographs and sold them out of their shops. A customer might send one to a distant friend or relative or keep it if there was something appealing about it. Some of Johnson's were of scantily clad women.[5]

Some stereographers saw the bigger picture and sought views that had an appeal beyond their limited geographic area. In 1904 the most successful of these were Elmer and Bert Underwood, who created the Underwood &

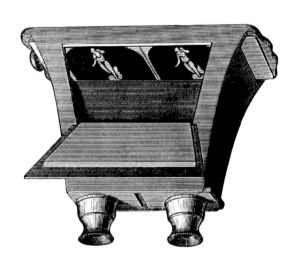

figure 2. Brewster stereoscope

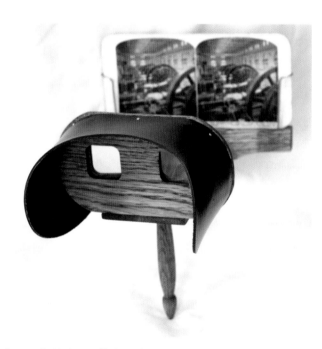

figure 3. Holmes-Bates stereoscope

2. Charles W. Carter Glass Negative Collection, Circa 1860–1900, LDS Church History Library, PH 1300, online at history.lds.org/section/library.

3. Johnson Company Stereograph Collection, Circa 1898–1902, LDS Church History Library, PH 215, online at history.lds.org/section/library.

4. C. R. Savage Collection, BYU Harold B. Lee Library Digital Collections, lib.byu.edu/collections.

5. See Mary Campbell, *Charles Ellis Johnson and the Erotic Mormon Image* (Chicago: University of Chicago Press, 2016).

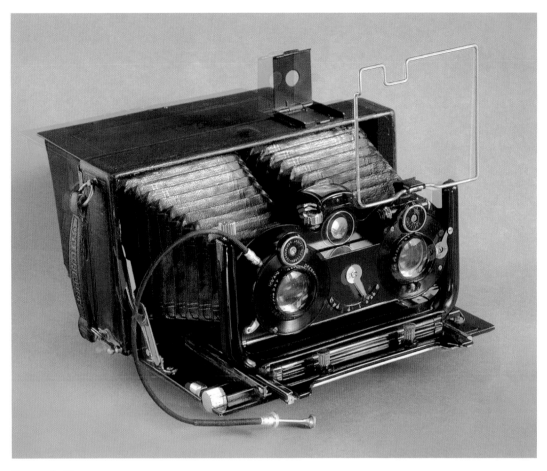

figure 4. Stereo camera

Underwood studio in 1897. At its peak the Underwoods were selling ten million views a year, thanks to enthusiastic agents who peddled the stereographs door-to-door.[6]

A customer in rural Utah might be offered a stereoscope containing a picture of US President William McKinley or, equally possible, an image of Utah's first governor, Heber M. Wells. The salesman had a Manual of Instruction that taught him what to say:

> There he is, right before you, just like life. Isn't that remarkable? Is there anything else that man has made that could bring you face to face with the president [or governor] in this way? (Secure an answer to this question.) You can see that this will be the best possible record for all future time of just the way a man looks in life. How much we would give to look across that desk at Lincoln or Shakespeare! This was made by our Mr. Strohmeyer, and is but one of [the images in] our fine statesman series, including the most prominent men of all parties—*all taken from life*. A photograph of this kind must become more and more valuable as time goes on.[7]

In real life, three dimensions are the normal way of seeing. For instance when you hold your hand out, you can perceive that it's closer to you than the objects behind it. The 3-D photographs, on the other hand, require a viewer of some kind to simultaneously place two slightly different views in mind. Stereographs were popular because they gave the impression of being at the actual spot and seeing

6. William Brey, "Ten Million Stereo Views a Year," *Stereo World*, Jan-Feb 1990, 6-12.

7. *Manual of Instruction* (New York: Underwood and Underwood, 1900), 12. A scan of the manual is available online at the *Library of Congress* website, https://lccn.loc.gov/00005284.

people and objects as you would if you were actually there when the photo was made.

Stereoscopes are bulky, however, and were usually packaged separately. We decided that for this book, we would print the original images in red and blue (cyan actually), using a process developed by the French photographic pioneer Louis Ducos du Hauron in 1895, in which two slightly different images printed on top of each other in contrasting colors provide the desired effect. In this case, glasses with matching color filters allow one to see the red image through the blue filter, while the blue image becomes invisible, and vice versa. Ink printed onto paper has a limited spectral range, so some of the opposing colors will bleed through, creating what is known as ghosting. Even so, it will be faint enough that the effect will be noticeable, dependent to some degree too on the color of light illuminating the page.

The history of the LDS Church, extending back to nineteenth-century New York, is interesting enough to lend itself well to the stereoviews presented in this book. Older Mormons who had migrated west had fond memories of the sites where the events occurred. By the turn of the twentieth century, however, many people in Utah had never been to New York and could only imagine what the sites looked like. It had been less than a decade since it had even become possible to print photographs in books and newspapers. Everyone had heard about these locations in church, and read written accounts. In 1888 three men, Andrew Jenson, Edward Stevenson, and Joseph S. Black, went on a history-gathering trip to these places and wrote to the *Deseret News* describing their experiences.[8] The photographs they took were not widely distributed. Despite the well known proverb, a thousand words cannot compensate for a decent picture.

The president of the LDS Church in 1904 was Joseph F. Smith, a son of Hyrum Smith and brother of the prophet Joseph Smith Jr. Joseph F. was a cousin of Joseph Smith III, president of the Missouri-based Reorganized Latter Day Saint (RLDS) Church, whose father, Joseph Jr., was revered by both churches as their founder. In 1873 the RLDS Church obtained possession of the Kirtland Temple in Ohio. Church president Joseph III had paid $150 for a quit-claim deed to own the building, and this was upheld in court in 1901 when a judge decided the Reorganized Church had occupied the property so long that there was *de facto* ownership.[9] This decision must have lit a spark in Utah, because that same year marked the beginning of the Utah church's interest obtaining real estate relating to church history in the Midwest and East Coast regions.

As various historic sites came onto the market in the twentieth century, the LDS Church began to buy a few of them. The Carthage Jail was the site where Joseph and Hyrum Smith, fathers and uncles to both Joseph F. and Joseph III, were killed in 1844. Understandably, Joseph F. Smith had no affection for the building, but when it became available for sale in 1903, Joseph F. Smith directed the church to purchase it for $4000, the equivalent of $108,000 today.

The greater prize for any church would be a specific spot in Independence, Missouri, on a grassy hilltop that had been designated in 1831 by Joseph Smith as the site for a future temple. That year Smith's agents purchased 63¼ acres for the temple and surrounding land, but when the Saints were driven from the area during the 1838 Mormon War in Missouri and had not yet built a temple, hopes of being able to diminished. Even so, according to a revelation dictated by Joseph Smith in September 1832,

8. Reid L. Neilson, Justin R. Bray, and Alan D. Johnson, eds, *Rediscovering the Sites of the Restoration: The 1888 Travel Writings of Mormon Historian Andrew Jenson, Edward Stevenson, and Joseph S. Black* (Provo: BYU Religious Studies Center, 2005), 286.

9. Kim L. Loving, "Ownership of the Kirtland Temple: Legends, Lies, and Misunderstandings," *Journal of Mormon History* 30, no. 2 (Fall 2004), 72–73.

Independence was the location of the future millennial city of peace:

> Which city shall be built, beginning at the temple lot, which is appointed by the finger of the Lord, in the western boundaries of the State of Missouri, and dedicated by the hand of Joseph Smith, Jun., and others with whom the Lord was well pleased. Verily this is the word of the Lord, that the city New Jerusalem shall be built by the gathering of the saints, beginning at this place, even the place of the temple, which temple shall be reared in this generation. For verily this generation shall not all pass away until an house shall be built unto the Lord, and a cloud shall rest upon it, which cloud shall be even the glory of the Lord, which shall fill the house.[10]

There was considerable debate upon the meaning of the word *generation* in this revelation, but whatever interpretation one might give it (historical or mystical), that grassy hilltop was obviously an important site to LDS people of all varieties, because whichever church could raise a temple there was promised that the glory of the Lord would descend upon it. Unfortunately for the LDS and RLDS Churches, sometime between 1867 and 1874 another branch of Joseph Smith's restoration movement, equally aware of the prophecy—calling itself the Church of Jesus Christ Temple Lot, or Hedrickites—was able to purchase the central 2½ acres where the temple itself would someday be situated. The RLDS Church decided to purchase adjacent property before 1884 and constructed a chapel there in 1888. In court it claimed to own the 2½ acres as well, and was awarded the property in 1894 only to lose it two years later on appeal by the Hedrickites. In the ensuing years, both the LDS and RLDS Churches bought additional nearby land, the Utah church finding twenty-six acres of the original property available in 1904,

on part of which the LDS visitor center now stands.[11] The RLDS Church built its headquarters and conference center called the Auditorium on adjacent land between 1926 and 1958 and added a temple in 1994 across the street from the Temple Lot church headquarters. By the twenty-first century, the LDS Church had more than 100,000 members in the area. In 2010 an LDS temple was built at Shoal Creek, ten miles north of the Temple Lot.

In 1905, a year after the Utah church purchased its land in Independence, it acquired the lot near Royalton, Vermont, where Joseph Smith was born. Two years later in 1907, it bought the Joseph Smith Sr. home near Palmyra, New York, while the RLDS Church attempted two years later to buy property in Nauvoo, Illinois, but was unable to do so because of opposition from neighbors. In 1928 the Utah church bought the Hill Cumorah in Palmyra, New York. A decade after that, in 1937, the Utah denomination purchased land in Nauvoo and acquired what remained of the jail in Liberty, Missouri. In 1944 they bought the remote valley of Adam-ondi-Ahman in northwest Missouri.

Eventually the LDS Church came to see the value in these properties, not just as religious sites to be preserved as part of the church's heritage, but also as pilgrimage destinations and for proselytizing opportunities in entertaining tourists. All of this may have begun in 1903 when the LDS Church purchased a home from a woman named Elizabeth Browning. The home was previously known as the Carthage Jail. With no immediate need, the church rented it to an educator, John Albert Califf, and he raised his family there. The lease agreement stipulated that he would show visitors the interior, to which he agreed and charged a fifteen-cent admission. As he notes in the 1904 guidebook

10. Doctrine & Covenants 84:3-5; RLDS D&C 83:1c-2b.

11. Brian Q. Cannon, "Long Shall His Blood ... Stain Illinois": Carthage Jail in Mormon Memory," *Mormon Historical Studies*, 10, no. 1 (Spring 2009): 6; online at mormonhistoricsites.org.

preface, "Among these visitors were many Latter-day Saints who were deeply interested in this historic scene."

In those days travel was expensive and time consuming, and those who could afford it had to ride for days on a train, then once arriving near a site they had to engage local transportation and a guide to help them find their way around. The frequency of visits to his home in the face of these obstacles led Califf to think that a set of stereographs would make it possible for others to appreciate key sites in their church's history without having to actually travel to them. Rather than attempt the photography himself, he engaged the services of a skilled stereographer. "The negatives for the views were taken by H[enry] A. Strohmeyer, artist, connected with the firm of Underwood & Underwood of New York, and President Roosevelt's official photographer."[12]

Califf accompanied Strohmeyer through New York, Ohio, Missouri, and Illinois to show him the scenes to be photographed. Afterward Califf travelled all the way to Utah, accompanied by son Jean Paul and friend Lee Caldwell. On June 20, 1904, the three paid a visit to the LDS presidency in Salt Lake City "with a request that someone be selected to write the description of these places for publication."[13] As noted in the Journal History kept by the Church Historian, after Califf "showed them views of places of interest mentioned in the history of our Church," the First Presidency requested Brigham H. Roberts to prepare "a booklet containing accurate descriptions" and gave Califf "a general letter of introduction, recommending the views."[14]

Brigham Henry Roberts was, at the time, editing the church's official history for the early period, so he was intimately acquainted with the material. He had been appointed Assistant Church Historian two years earlier, under apostle Anthon H. Lund. A nationally recognized figure, Roberts had been elected to the US House of Representatives in 1898 but was refused his seat because he was a polygamist, which is how he ended up spending the years between 1902 and 1912 preparing the six volumes of the *History of the Church of Jesus Christ of Latter-day Saints* for publication, drawing on the writings of Joseph Smith's scribes in the *Times and Seasons, Millennial Star*, and *Deseret News* from 1839 to 1856, then fact-checking, annotating, and supplementing the history with additional documentation. Beginning in 1909 Roberts covered the same ground in a series of articles on Mormonism written by himself for the history magazine *Americana*, which he would later revise and expand to create the six-volume *Comprehensive History of the Church*. The 132-page booklet created to accompany the stereographs became one of Roberts's rarest publications because of its size and shape, the dimensions matching those of a stereograph card, and easily discarded.

As soon as the booklet was printed, Califf placed a want ad in the *Deseret News* on August 15, 1904: "Salesmen— Every Settlement / to sell Latter Day Saint's Tour: Designed by Prof. Califf of 'Old Carthage Jail,' Carthage, described by Elder B. H. Roberts. Write or call on Califf, 620 Templeton Bldg., City. References required, liberal terms."[15]

Only one advertisement has been found, so we might assume that Califf was so quickly overwhelmed by applicants that there was no need for a second ad. Salesmen fanned out across Utah, undoubtedly encouraged to use high-pressure techniques even though the topic was

12. John A. Califf, "History Told by the Camera," *Deseret Evening News*, June 30, 1904, 3.

13. "Truth Told regarding Prophet's Burial Place," *Deseret News*, Jan. 31, 1928, 6.

14. Church Historian's Office, Journal History of the Church, June 21, 1904, 3.

15. "Wanted," *Deseret News*, Aug. 15, 1904, 10.

Henry A. Strohmeyer, photographer for *The Latter-day Saints' Tour*, who was previously the official White House photographer under President Theodore Roosevelt

already dear to the hearts of the target customers. Each salesman memorized portions of the Underwood *Manual of Instruction* to provide a ready answer for any possible objection. If those who answered the door weren't Mormon, the salesman would undoubtedly make a quick transition to sell some other set of views by Underwood & Underwood with equal fervor.

The stereographs comprising the *Latter-day Saints' Tour* were stored in a box in a slip case shaped like a book. The company produced similar sets marketed to more general audiences, including 3-D tours of cities and foreign lands, reenactments of Bible stories, curiosities, the Spanish–American War, and portraits of US politicians. The sets were sold door-to-door in the summer by college students who were able to earn enough to pay their tuition and expenses for the coming year.

A listing in *Publishers Weekly* in January 1905 gave the price for *The Latter-day Saints' Tour* as $6.50, which would be about $176 in today's currency. It would have included the 38-card set and 132-page booklet, but not the stereoscope itself, which would have cost an additional 90 cents, or about $24 today.[16] These were expensive items. One can imagine that most people who purchased them would have had to sacrifice in order to obtain this piece

16. *Publishers Weekly*, Jan. 28, 1905, 93. For comparison sake, a price list for a *President McKinley Tour*, advertised at the back of a 1904 *Washington through the Stereoscope* set, offered twelve standpoints (stereographs) and a case for $2.10 or twenty-four standpoints for $4.00. A *President Roosevelt Tour* with thirty-six standpoints and case but no guidebook sold for $6.00.

of religious heritage. That said, it is not known how successful the venture was at first. Potential customers would have needed to be reassured that the sites pictured in the stereographs were actual LDS historic sites, that this was not an anti-Mormon scam.

For the version issued in 1905, the set was reduced to 29 stereographs[17] and the text describing the cards was reduced so that the booklet now had 102 pages.[18] A few of the views were replaced by others, as in the case of John Taylor's Nauvoo home which had turned out to be the wrong house. The reduced set, costing about $1.50 less, or $5.00, has been scanned and can be viewed online at the LDS Church History Library's website.[19] In order to overcome suspicions about the authenticity of the views, the 1905 version included the official endorsement of the LDS First Presidency.[20]

The value of the stereographs for missionaries was recognized by Ben E. Rich, president of the Southern States Mission. He wrote:

> A very interesting agency for the introduction of the Gospel of Jesus Christ into the homes of the people is the "Latter-day Saints' tour from Palmyra, N.Y., to Salt Lake City," conducted by Elder Brigham H. Roberts. It consists of twenty-nine very fine stereoscopic views, with a well-written narrative of the historic places shown. It is well known that at Palmyra, N.Y., and in the states of Ohio, Missouri and Illinois, are places dear to all members of the Church of Jesus Christ of Latter-day Saints. There occurred joys and sorrows, which give them the keenest historic and sacred interest. At Salt Lake City are places of like historic and religious interest,

which also show an institutional and industrial development that is of great interest to everyone. Each year many people visit these places, making the actual trip from state to state in order to learn more fully their history. Missionaries, before and upon their missions, find in visiting the historic spots shown, an enthusiasm which strengthens them in their work. But many more are they who are unable, for various reasons, to make this trip, which would be one of the fondest accomplishments of their life. The opportunity of traveling to these places is provided by the stereographs of this tour as seen through the stereoscope. Each and every view contains a history in itself of the rise or growth of the Church.

Among the scenes shown are the old Smith homestead—scenes of the Prophet's first visions and revelations; Hill Cumorah; Kirtland Temple; Temple lot at Independence; ruins of Liberty Jail; Adam-on-di-ahmon; Nauvoo Temple; Nauvoo Mansion House; burial lot where the murdered Prophet and Patriarch were buried; four views of Carthage Jail, showing stairway ascended by the mob, room where Joseph and Hyrum were assassinated and window from which the Prophet fell; Courthouse at Carthage; pictures of Joseph Smith, Joseph F. Smith, John R. Winder and Anthon H. Lund; homes of Lyman Wight, in Davis Co., Mo., and of Brigham Young, John Taylor, Lorenzo Snow and Wilford Woodruff at Nauvoo; the Temple and Tabernacle at Salt Lake City; interior of the Tabernacle, showing the great organ; Pioneer Monument; Main Street, Salt Lake City; Great Salt Lake and Pavilion at Saltair[;] City and County Building, and other interesting pictures.

Armed with a set of these views, an Elder will have no difficulty in interesting those whom he visits, making friends and ultimately, converts. Missionaries laboring in cities, and also the

17. The stereographs that were eliminated to create the 29-card set were 18, 25, 27–31, 35, and 37.

18. B. H. Roberts, *The Latter-Day Saints' Tour from Palmyra, New York, to Salt Lake City through the Stereoscope*, Ottawa, KS, 1905.

19. LDS Church History Library, PH 2198, history.lds.org/section/library; also PH 7965, box 1, folder 20.

20. The endorsement read: "Underwood & Underwood have taken a series of stereographs to show the historical places mentioned in the history of our Church. These stereographs are authentic and must be of special interest to our people. Accompanying the views is an interesting booklet written by Elder B. H. Roberts, giving an accurate description of each of them. Brother Roberts having been on the ground and having seen all of the places photographed." Official Commendation, Joseph F. Smith, John R. Winder, and Anthon H. Lund, Mar. 22, 1905, in *Latter-Day Saints' Tour*, 1905, 9.

Sunday Schools ought to have a set. There are fifty sets at the Mission office, and while they last they will be sold for cost.[21]

It is easy to imagine that with missionaries in some areas utilizing the stereographs, and with salesmen visiting rural Utah—and knowing the emotional content of the images for Mormons—the level of success must have been high, even though money was scarce in Utah. As one indication of the success of the version with fewer images, when Underwood & Underwood was bought by Keystone View Company in 1920, the latter continued to sell the 29-card set.[22]

In 1906 a Salt Lake City company produced a set of cards that attempted to duplicate Underwood & Underwood's accomplishment. The stereographer for Pan-American Publishing, J. B. King, displayed less skill, and with a camera that had a longer focal length, the stereoscopic effect was reduced. Some views, especially of inside the Carthage Jail, were severely restricted. The Hill Cumorah image was of a painting rather than of the actual hill, and there were other problems. That said, it included two pictures inside the Kirtland Temple, a view of Salt Lake City's Emigration Canyon as seen from Liberty Park, and portraits of all of the church presidents who preceded Joseph F. Smith, framed in flowers the way Califf had done but not in stereo. Instead of a booklet, a description of the view was printed on the back of each card. Like the Underwood product before it, the collection was peddled by door-to-door agents rather than through stores. An incomplete set of these views is available at the online Church History Library site.[23]

It is possible that the now-famous Utah photographer George Edward Anderson was inspired by these stereographs when he decided to take large-format 2-D pictures of the same sites on his way to an LDS mission to England in 1907. It was his images that received wide distribution and are still popular today.[24] Since then, thousands of Mormons have traveled back to see these historic and sacred sites, and other images and videos are now readily available. It is hard for us to imagine today the thrill someone experienced in the 1900s, sitting in an armchair viewing 3-D images from a stack of stereographs. It might be comparable to us seeing an IMAX movie for the first time today. However, other interesting forms of home entertainment eventually became available, and stereographs became less popular. Despite that, every so often they re-emerged in a different form—in the 1930s Tru-Vue stereo viewers with tightly rolled strips of 35-millimeter film that was fed into a lensed plastic viewer and in 1939 when the View-Master provided color 3-D views on circular disks, each disk containing seven separate views. Technology involving 3-D is now advancing once more with the goal of making movies and holograms readily accessible, along with virtual and augmented reality. It will be interesting to see what new forms of 3-D viewing develop in our lifetimes.

One of us (Steven and wife Cathy) attended a meeting of the Utah Stereoscopic Society on May 19, 2005, at the home of Ken and Linda Luker in Salt Lake City. During the meeting we passed around antique stereographs and viewers. One of the group, Marjorie Johannes who lives in Provo, had brought a set of thirty-seven cards that form the subject of this book, plus a few more views,

21. Ben E. Rich, "A Silent Missionary," *Elders' Journal*, Aug. 15, 1905, 377–78.

22. One of these boxed sets was available for a time through collector Jeffrey Kraus's *Antique Photographics* website as item S284.

23. LDS Church History Library, PH 4326. The missing views were probably of Liberty Jail (stereograph no. 7), Wilford Woodruff (no. 26), and the Saltair Pavilion (no. 34).

24. Richard Neitzel Holzapfel, T. Jeffry Cottle, and Ted D. Stoddard, eds, *Church History in Black and White: George Edward Anderson's Photographic Mission to Latter-day Saint Historical Sites* (Provo: BYU Religious Studies Center, 1995), 219; see also Holzapfel, "Stereographs and Stereotypes: A 1904 View of Mormonism," *Journal of Mormon History* 18, no. 2 (Fall 1992): 155–77.

all of which had been given to her long ago by a neighbor. Steve found them to be truly unusual knowing from having collected stereographs, that it was uncommon to find a set of cards that was still intact. Most antique dealers offer stereographs in random stacks, so that if any particular card once belonged to a specific set, that relationship had long since been forgotten. They are usually arranged by geographic location or subject without any thought to how they might have been originally marketed. And yet, here was a nearly complete set that was missing only one card, the image of Joseph Smith. Marjorie has since donated her collection to the Harold B. Library at Brigham Young University; but before she did, she allowed me to scan the images. As we did so, we thought they would make an interesting book, especially when we began researching the collection and discovered a copy of Roberts's 1905 booklet in the Utah Historical Society library, describing twenty-nine of the stereographs. Now we knew why they were considered important enough to keep together as a set.

Along the way we showed our scans to Ardis Parshall, then a researcher at the LDS Church History Library, who pointed us in the direction of additional resources and recommended that we show the booklet to photo archivist Bill Slaughter, who suggested the current publisher. Our neighbor Lynnette Hanson writes lessons for the Daughters of Utah Pioneers and is an admirer of B. H. Roberts's skill as an historian. She made a typescript from the 1905 pamphlet and attempted to provide descriptions for the cards that had none.[25] A few weeks later, the 1904 booklet was discovered, with Roberts's descriptions of all thirty-eight stereographs, online at the Library of Congress catalog, with a link to the *Internet Archive*

where a scanned copy resides.[26] Most of the images have since been made available online by the Church History Library.[27] Later on, while at the library, we encountered Joseph Johnstun of Carthage, Illinois, who was studying Joseph Smith's martyrdom. He had been in contact with a relative of John Califf and told us the story of how these views came to be. Marjorie's stereographs were uneven, faded, and had been heavily used, and so we selected the best views from various collections at the Church History Library and had them scanned.

We appreciate the effort of the library's staff, especially Anya Bybee, who provided scans of the stereographs in their collections. We are grateful to John Hatch, Ron Priddis, and Jason Francis of Signature Books, whose enthusiasm for this project and creative abilities made this book possible.

25. The 1905 booklet may now be seen online at the LDS Church History Library site as PH 7965, box 1, folder 20.

26. The Library of Congress has the booklet cataloged as unk82054751; one is directed to archive.org/details/latterdaysaintst00robe.

27. LDS Church History Library, PH 2198, PH 4321–23, PH 4325, PH 7965.

THE
LATTER-DAY SAINTS' TOUR

FROM PALMYRA, NEW YORK,
TO SALT LAKE CITY,
THROUGH THE STEREOSCOPE

A History of the Church of Jesus Christ of Latter Day Saints, Embodied in Descriptions
of Original Stereographs of Noted Persons, Famous Buildings, and Interesting Scenes
Connected with the Story of the Origin, Struggles and Growth of the Mormon People

DESIGNED BY JOHN A. CALIFF

AND DESCRIBED BY B. H. ROBERTS,

author of *The Life of John Taylor*, *Outlines of Ecclesiastical History*, *The Gospel*,
A New Witness, *Mormon View of Deity*, etc.

THE DESERET NEWS
SALT LAKE CITY
1904

PREFACE

It seems fitting that the readers of this monograph be given an account of how it came to be written and the purposes for which it is submitted to the public.

At present I occupy the residence known as the Old Jail, of Carthage, Hancock County, Illinois. During the past year it has been my privilege and pleasure to show hundreds of people through this building, made historic by the murder of the Prophet Joseph Smith and his brother Hyrum within its walls. Among these visitors were many Latter-day Saints who were deeply interested in this historic place.

The persecutions which began at Palmyra, New York, and continued throughout Ohio, Missouri and Illinois, and which resulted finally in the establishment of the Church in Utah, have been the subject of many books, but in none, it seems to me, heretofore presented to the public, has full advantage been taken of modern art to preserve, for a purely historic treatment, the atmosphere surrounding the acts, teachings and persecutions of the Prophet Joseph Smith.

Human toil and human suffering, when endured for the sake of human well-being, render places not only memorable, but lovable—yea, sacred. This is true even of secular affairs. The fields on which liberty has been wrested from the hands of tyrants are sacred to all humanity. Bunker Hill is to all Americans more than a hill. The monument there erected is but a marker, the real monument is the hill itself, dedicated to the spirit of liberty and endeared to the hearts of a liberty-loving people on the very day when the blood of New England patriots was there shed. And how much this sacredness of place affects mankind is evident. It is this that induces travelers every year by thousands to visit the world's famous battle fields, the birth places and the tombs of the heroes, sages and poets of all lands and all ages. Nor can it be questioned that the thoughtful traveler returns from such scenes with a new and finer sense of the essential dignity and justice of humanity.

Just as man is a dual being, body and spirit, so also history may be said to have a like duality, the scenes and places of man's great deeds being the body, and the informing spirit that wrought these deeds, the soul of history. Nor can the one be considered apart from the other without a distinct loss. Modern art provides a way for preserving for all future ages this body of history, these places and scenes where great souls have blazed the way for truth and for humanity.

Under the corroding influences of time and decay, as well as through the changes made in the face of nature, those places and scenes soon lose their pristine appearance, if not their identity. In view of these considerations, it seems to me, that this is a fitting time to give to the history of the persecution of Joseph Smith and his followers, and of the founding of the Church in the western desert, a body, the best that art can give. Hence, this series of stereoscopic photographs by the foremost artist of the times, accompanied by narration and description from the pen of the well-known writer, B. H. Roberts, who has personally visited all these scenes—is submitted to the public as a stereographic history of the Church of Jesus Christ of Latter-day Saints, the value of which will increase as the years go by.

That these stereographs, with their descriptions, may prove a valuable and interesting addition to the literature of the Church, is the sincere hope of the designer of this work.

John A. Califf
"The Old Jail," Carthage, Illinois
June, 1904

PUBLISHERS INTRODUCTION

At Palmyra, New York, in the states of Ohio, Missouri, and Illinois, are places dear to all members of the Latter-day Saints Church. There occurred joys and sorrows, successes and reverses, which give them the keenest historic and sacred interest. At Salt Lake City are places of like historic and religious interest, which also show an institutional and industrial development that is of tremendous interest to everyone. Each year many of the Latter-day Saints visit these places, making the actual trip from state to state, in order to learn more fully their history and to drink more deeply at the fountains of inspiration that flows therefrom. Missionaries, before and upon their travels, find in visiting these spots an enthusiasm that strengthens them in their work. But many more are the Latter-day Saints who are unable, for various reasons, to make this trip, which would be one of the fondest accomplishments of their life.

The opportunity of traveling to these places is provided by the stereographs of this tour as seen through the stereoscope. No longer is required a heavy expense and great loss of time. No longer is the pleasure limited to the few. What you will get at each standpoint which you take, through your eyes aided by the stereoscope lenses, is the experience of standing in the different places, exactly where the stereoscopic camera stood. That special kind of camera has two lenses, placed side by side like your own eyes. You will see with your right eye exactly what was taken in by the right lens of the camera, and with your left eye, exactly what was taken in by the left lens. Looking through the stereoscope with both eyes at once, you will, therefore see everything before you just as you would if you were bodily on the spot where the stereograph was taken, an effect impossible with a common picture or an ordinary photograph made with a single lens. These stereographs seen through the stereoscope carry a person away from his own locality, over the route from place to place settled by the early members of the Church. More than that, the traveler will survey the places, not in miniature, but in full life size; with the full effect of being present right on the spot, collecting the same ideas, receiving the same mental impressions, and experiencing the same emotions of reverence, inspiration, joy and sadness, pleasure or pain, as would be created by an actual visit to the places themselves.

As a guide for you in this travel, we are glad to be able to supply you with narration and description from the pen of the well-known author, Brigham H. Roberts, who has personally visited all these places.

The early history of the Church of Latter-day Saints, its origin, its early growth and its persecutions, has been the subject of many books. But not until the making of this stereographic record with the historical descriptions of Elder Roberts, has fullest advantage been taken to preserve the atmosphere surrounding the acts, teachings and persecutions of the Prophet Joseph Smith. The last few are stereographs from Utah. They show what determination, energy, zeal, and cooperation will do for a people directed by a mastermind. These places stand as fitting monuments in the greatest religious movement of the nineteenth century. Thus each and every stereograph contains a history in itself of the rise or growth or proud accomplishment of the Church of Latter-day Saints. For travel and its attendant results of pleasure and instruction, for recording the history of the Latter-day Saints Church in a clear and impressive manner, how valuable must be this collection of stereographs! It will be a most valuable acquisition to every Mutual Improvement Association, to every Sunday School, to every public library, and to every family among the Latter-day Saints. It will enable the missionary to carry his Gospel story with increased vividness and power.

That these stereographs with their descriptions may prove a valuable and interesting addition to the literature and history of the Church, and that they may in a real way provide the very trip outlined, are the sincere hopes of the publishers.

ITINERARY

1. Joseph Smith the Mormon Prophet and Founder of the Church of Jesus Christ of Latter-day Saints.

2. The Old Smith Homestead—Scene of Joseph's First Visions and Revelations—near Palmyra, New York.

3. Cumorah Hill, where the Prophet Received the Golden Plates or Records of the Book of Mormon, near Palmyra, New York

4. The Mormon Temple at Kirtland, Ohio—59 x 79 feet, cost $70,000, dedicated March 27, 1836.

5. North over Temple Lot. Site Marked by Mormon Prophecy for World's Greatest Temple, Independence, Missouri.

6. Ruins of Jail where Joseph Smith, Hyrum Smith, and other Mormon Leaders were Imprisoned, Liberty, Missouri.

7. Apostle Lyman Wight's House at Adam-ondi-Ahman, near Gallatin, Daviess County, Missouri.

8. Looking East Along Mulholland Street from South Side of Temple Block, Nauvoo, Illinois.

9. The Temple of Nauvoo, Illinois, 88 x 128 feet, Corner Stone Laid April 6, 1841; burned November 10, 1848.

10. Home of President Wilford Woodruff, Nauvoo, Illinois, Facing East.

11. Home of President Lorenzo Snow, Nauvoo, Illinois.

12. Nauvoo Mansion, Home of Joseph Smith, from which Murdered Brothers were Buried, Nauvoo, Illinois.

13. Old Smith Homestead, Emma Smith's Grave, and Lot where Martyred Brothers were Buried, Nauvoo, Ill.

14. Home of President Brigham Young, Nauvoo, Ill., Facing North.

15. Home of President John Taylor, Nauvoo, Ill., Facing East.

16. The Old Jail where the Prophet Joseph Smith and His Brother Hyrum were Murdered, South Front, Carthage, Illinois.

17. Hall Door to Debtor's Prison, Stair way Ascended by Mob and Door to Main Prison, Jail, Carthage, Ill.

18. Door to Main Prison, Hall where Mob Stood while Firing into Jailors' Parlor, Jail, Carthage, Ill.

19. Jailor's Parlor where Mob Slew Joseph and Hyrum Smith; Bullet Hole in Door—Old Jail, Carthage, Ill.

20. East Side of Jail, Showing Window where Joseph Smith was Shot and from which he Fell, Carthage, Ill.

21. Courthouse, Scene of Trial of the Murderers of Joseph and Hyrum Smith, Carthage, Ill.

22. Brigham Young, the Great Leader of the Nauvoo Exodus, and Colonizer of the American Desert.

23. The Great Temple and the Tabernacle, Cost of Temple $4,000,000, height 210 feet, Salt Lake City, Utah

24. Pioneer Monument, in Honor of Brigham Young and Pioneers of July 24, 1847, Salt Lake City, Utah.

25. The East Side of Temple Block, looking North, Salt Lake City, Utah.

26. Interior of the Tabernacle, Seating 8,000, and the Great Organ, Salt Lake City, Utah.

27. Assembly Hall, Temple Block—Gothic Architecture, Seating Capacity 3,000, Salt Lake City, Utah.

28. The Beehive House, Official Residence of President Joseph F. Smith, Salt Lake City, Utah.

29. The Lion House and the Great Temple at Distance, Northwest, Salt Lake City, Utah.

30. Amelia Palace, Last Official Residence of Brigham Young, Salt Lake City, Utah.

31. Grave of Brigham Young, Salt Lake City, Utah.

32. Courthouse—City and County Buildings— height 256 feet, cost $800,000, Salt Lake City, Utah.

33. Salt Lake City Northwest from the Courthouse—the Temple at Distance, left—Utah.

34. Looking Southeast Along Main Street, Salt Lake City, Utah.

35. Great Pavilion at Saltair Beach, Salt Lake, 13 Miles due West from Salt Lake City, Utah.

36. Great Salt Lake and the Pavilion—Bathing Scene, Showing Density of water in Great Salt Lake.

37. Hon. Heber M. Wells, Governor of Utah, in His Office, Salt Lake City.

38. President Joseph F. Smith, left, and Second Counselor Anthon H. Lund, center. First Counselor John R. Winder, right.

HOW TO SEE STEREOSCOPIC PHOTOGRAPHS

(A) Experiment with the Sliding Rack, etc.

(B) Have a Strong, Steady Light on the Stereograph.

(C) Hold the Stereoscope with the Hood Close against the Forehead, etc.

(D) If a Clear Idea is not Obtained of each Stereograph from the Description Given, Read the Statement in Points of View and Directions, that Refers to the View that you are Studying, etc.

(E) Do Not Look Over the Stereographs too Rapidly, etc.

The 1905 version had an expanded description of how to use the stereoscope: 1st. Always sit so that a strong, steady light falls on the face of the photograph. Sit with your back to the light, having the light come over your shoulder. 2d. Hold the hood of the stereoscope close against the forehead, shutting off entirely all immediate surroundings. The less you are conscious of things close about you the stronger will be your feeling of actual presence in the places you are visiting. 3d. Move the sliding rack when holding the first stereograph back and forth along the shaft to the place where the object in the scene can be observed most distinctly. This place varies greatly with different people. 4. Study each stereograph long and thoughtfully. Enumerate to yourself all the objects which you see and the thoughts which they suggest. Always feel being away from home at the place visited. Then read the description of the particular stereograph, referring again and again to the stereograph to see the facts brought out in the description. An excellent plan is for one to study the stereograph, having another read; then reverse. Read also your books bearing upon these subjects. 5th. Go slowly. Don't think you can see them all at one sitting. Better study a few and read the references and think them over, and then take a few more. 6th. Visit these places again and again. You will be surprised to find how many new objects are seen and new ideas brought to mind by each repeated trip. Remember that you are visiting historic and sacred places. They should be visited over and over again. They are worth your deepest thought and most reverent spirit.

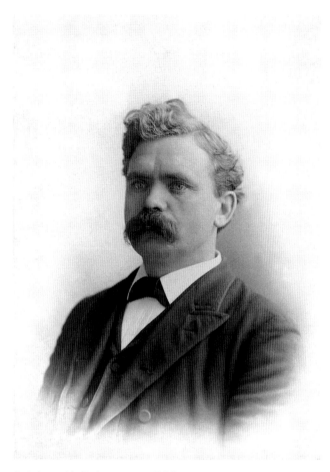

Brigham H. Roberts, ca. 1895.

A GENERAL VIEW OF MORMONISM

Mormonism, from whatever point of view considered, is an interesting subject. The truth of the assertion is obvious with reference to those who accept it as a divine institution; but we hold that it is scarcely less interesting to the general reader and the student of religious phenomena. The latter will find in it all those elements usually connected with religious world movements. On the part of the leaders in Mormonism he will see exhibited the force that comes of a self-conscious inspiration that for its origin refers to God; on the part of the followers he will see exhibited that faith which becomes a passionate intuition; and in the union and activity of these two forces he will recognize the religious power that braves all danger, that overcomes all obstacles, that knows no defeat; and leads to such exaltation of mind that men under its influence take joyfully the spoiling of their goods, out of weakness are made strong, wax valiant in fight, count as nothing the attacks of their enemies, endure all things, hope all things; and though troubled on every side, yet are they not distressed; perplexed, but not in despair; persecuted, but not forsaken; cast down, but not destroyed. This is the force which in Moses and the Hebrew race, founded the commonwealth of Israel; that in Christ and the apostles, founded the Christian Church; that in Mohammed and his following, established Islam. As for the general reader, though he may take no delight in an analytical study of Mormon thought and doctrine, if he has an admiration for human achievement in the face of seemingly insurmountable obstacles; if his soul may be touched by pathos, or thrilled by heroism; if he delights to dwell on things involving high adventures—the founding of states, the redeeming of deserts, the struggle of civilization against savagery, as well as struggles in the world of ideas, he will find all these in infinite variety in Mormonism; and hence to him, as we contend, Mormonism will be a subject of intense interest.

When allowed to represent themselves the Latter-day Saints insist that Mormonism is no new religion, but a new dispensation of Christianity; not a new institution, but the re-establishment of an old one—the Church of Jesus Christ. This new dispensation of the old Christian faith, this latter-day founding of the Church of Christ, became a necessary work because men in the early Christian centuries departed from the faith once delivered to the Saints, and finally paganized and destroyed the Church of Christ by transgressing the laws of God,

changing the ordinances of the gospel, and breaking the covenant that had been made with God—hence a spiritual darkness covered the world that could only be dispersed by a new dispensation of the gospel of Christ, and a re-establishment of the Christian Church. This restored gospel, this re-established Church of Christ is Mormonism.

This modern dispensation of the Christian religion and the re-establishment of the Christian church took place in western New York, in the region of country south of Lake Ontario; Palmyra, in Wayne County; Manchester, in Ontario; and Fayette, in Seneca, being the chief centers of its early activities. From these centers where Mormonism may be said to have been roughly cradled, it made its forced marches across the continent to its present commanding position in the Rocky Mountains, where it challenges the investigation of the world.

It is a mistake to think of Mormonism any longer as limited by the boundary lines of the state of Utah. It has passed over these boundary lines in every direction. Its colonizing enterprises extend from the province of Alberta, Canada, to the north part of the state of Chihuahua, Mexico, a distance, as the crow flies, of some eighteen hundred or two thousand miles; while east and west its colonies extend into Wyoming and Colorado, Nevada and Oregon. Mormonism then lies across the pathway of all transcontinental travel; no journey can be made from the sea east to the sea west without touching it at some point, and so with the journey from the west sea to the east.

The story of the origin of Mormonism is in itself both interesting and instructive. Joseph Smith, the Mormon prophet, for whom the world as yet can give no satisfactory accounting, when a mere lad—fourteen years of age—was much disturbed by the sectarian divisions and bitterness in his own neighborhood, the vicinity of Palmyra. Though necessarily limited in his experience and immature in judgment, to him this strife was incongruous and altogether out of keeping with that spirit that should characterize the true Christian religion. In the midst of the war of words and tumult of opinions that raged about him he frequently asked, "What is to be done? Who of these parties are right, or are they all wrong together. If any one of them be right which is it, and how shall I know it?" In the midst of these perplexities he read in the epistle of James, "If any of you lack wisdom let him ask of God that giveth to all men liberally and upbraideth not, and it shall be given him." Acting upon these instructions he claims to have received in answer an open vision of the Lord God and His Son Jesus Christ, who informed him, in answer to his questions, that none of the sects of religion about him were right; that all their creeds were an abomination in God's sight; that the professors thereof drew near to Him with their lips, but their hearts were far from Him; that they taught for doctrine the commandments of men; that they had a form of Godliness, but denied the power thereof. He was forbidden to join any of them, but received the promise that the fullness of the gospel would at some future time be made known to him.

Three years later Joseph Smith claims to have been visited by another heavenly messenger, direct from the presence of God, who revealed to him the existence of the Book of Mormon, an abridged record of the ancient inhabitants of America, engraven upon gold plates, and hidden in a hill adjacent to his father's residence, and called by the ancients "Cumorah." This record contains the history of the ancient inhabitants of America, an account of their migrations from the old world to the new, and the expansion of these colonies into great empires and republics. It gives an account also of the advent of the Savior in the western hemisphere after His resurrection, and the establishment of the gospel of Christ and the organization of His Church among the inhabitants thereof. It is not only an important history of ancient America, but a valuable volume of scripture. Subsequent ministrations of angels—of John the Baptist, now raised from the dead; also of Peter, James and John—the three chief apostles of Jesus in a previous dispensation of the gospel—resulted in conferring upon the prophet of the new dispensation divine authority by which he was authorized to preach the gospel and administer its ordinances. By virtue of this authority, on the 6th day of April, 1830, he organized the Church of Christ in Fayette, New York, where resided the Whitmers and Oliver Cowdery, who became his ardent supporters and assistants in the work.

All this was not accomplished without violent opposition. The world seldom takes kindly to innovators, and least of all to religious innovators, especially such an innovator as Joseph Smith, who began his prophetic career by proclaiming, as a messenger from God, that the sects were all wrong and their creeds an abomination, and predicting the coming forth of a system of religious truth which would supplant them. The vexation of sectarian ministers at first found expression in ridicule, then in denunciation, in malignant persecutions, and finally in acts of mob violence. But no matter; the Church of the new dispensation had been founded, and was started upon its marvelous career.

On its forced march from New York westward, the Mormon Church, or, to use its official name, the Church of Jesus Christ of Latter-day Saints, halted in Ohio, in Missouri, and Illinois. Wherever it halted it made history, and left monuments; and it cannot be otherwise than that these monuments no less than the tabernacles and temples it has builded and the cities it has founded in the Rocky Mountains of the west, are all interesting. It is these considerations which have led to the publication of this series of stereographs, which mark the wayside stages of the Mormon Church in its movements from Palmyra to Salt Lake, and the publishers are of opinion that they are conferring a public benefit by enabling their readers to follow step by step the progress of this greatest of all modern religious movements.

1 Joseph Smith, the Mormon Prophet and Founder of the Church of Jesus Christ of Latter-day Saints

"It is by no means improbable," writes Josiah Quincy in 1844, "that some future text-book, for the use of generations yet unborn, will contain a question something like this: What historical American of the nineteenth century has exerted the most powerful influence upon the destinies of his countrymen? And it is by no means impossible that the answer to that interrogatory may be thus written: *Joseph Smith, the Mormon prophet*. And the reply, absurd as it doubtless seems to most men now living, may be an obvious commonplace to their descendants."

If such a probability as this could be impressed upon the mind of a man of such intelligence as Josiah Quincy in 1844, how much more probable must this prediction appear after sixty years of rough experience has tested the institutions founded by Joseph Smith only to prove them more vigorous than during his lifetime, and daily extending their influence over more territory and more people.

Joseph Smith was born on the 23rd of December, 1805, in Sharon, Windsor County, in the state of Vermont, United States of America. When the Prophet was ten years of age his parents migrated to the state of New York and settled near Palmyra; afterwards removing to Manchester Township, in the same State. Here, at the age of fourteen, began those religious perplexities and questionings in the youthful mind of the future prophet of the 19th century which resulted in the great visions and revelations on which are based the doctrines and organization of the Church of Jesus Christ of Latter-day Saints, commonly called the "Mormon Church."

The life's work of the prophet was attended with every conceivable difficulty, from the announcement of his first revelation to the close of his career by martyrdom at Carthage, Illinois, on the 27th of June, 1844. His life was beset with difficulties ranging from ridicule of his pretentions to the most violent and brutal attacks upon his person, and finally to assassination itself. Fifty times was he dragged before the courts of his country, where every variety of false charges was made against him, and fifty times was he dismissed from custody uncondemned. Time and again the waves of adversity seemed to overwhelm him, but each time he arose in greater majesty and power; and, as he himself once said, "wafted by them nearer to Deity." Sure it is that each new persecution endeared him the more to the hearts of his people, and he lived to realize the fulfillment of his own prediction, viz., that his people should never be turned against him by the testimony of traitors. Few men—none—ever ranged so completely the gamut of human experience, or tasted so fully life's commingled joys and sorrows as did this man. Reviled, yet honored; derided as an impostor, yet accepted as a prophet; persecuted, yet not forsaken; cast down, but not destroyed; his very death was a triumph, a martyrdom, and his blood ruthlessly shed

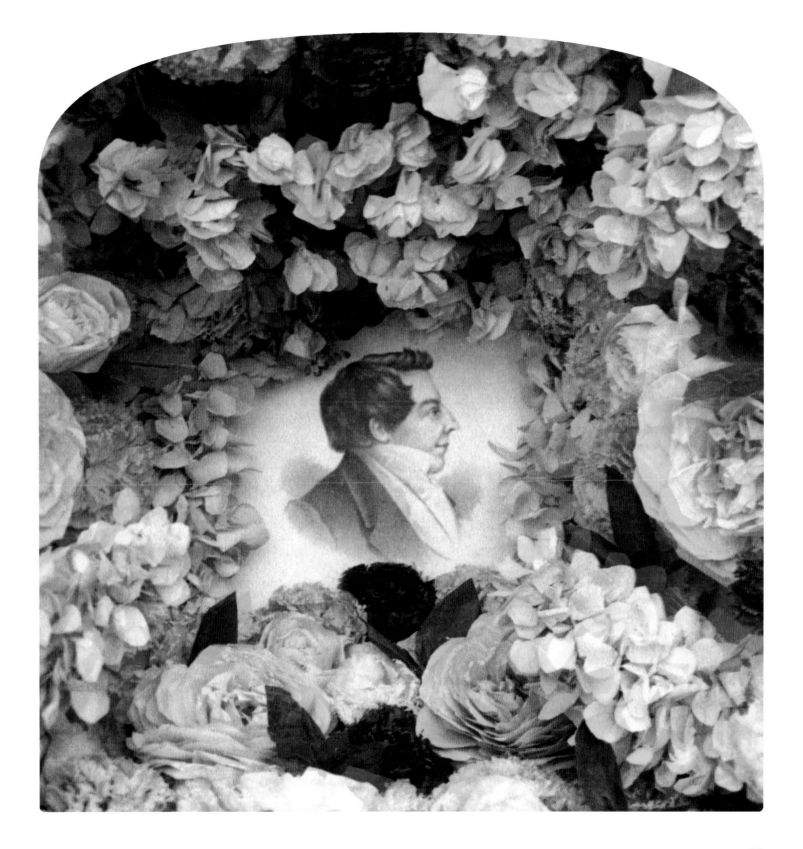

by assassins affixed a broad seal to his testimony and made it of force in all the world. His person and character are most happily described by a disciple who knew him well and shared his sorrows and triumphs for many years, and finally himself became a martyr in the same cause:

President Joseph Smith was in person tall and well built, strong and active; of a light complexion, light hair, blue eyes, very little beard, and of an expression peculiar to himself, on which the eye naturally rested with interest, and was never weary of beholding. His countenance was ever mild, affable, beaming with intelligence and benevolence; mingled with a look of interest and an unconscious smile, or cheerfulness, and entirely free from all restraint or affectation of gravity; and there was something connected with the serene and steady penetrating glance of his eye, as if he would penetrate the deepest abyss of the human heart, gaze into eternity, penetrate the heavens, and comprehend all worlds.

He possessed a noble boldness and independence of character; his manner was easy and familiar; his rebuke terrible as the lion; his benevolence unbounded as the ocean; his intelligence universal, and his language abounding in original eloquence peculiar to himself—not polished— not studied—not smoothed and softened by education and refined by art; but flowing forth in its own native simplicity, and profusely abounding in variety of subject and manner. He interested and edified, while, at the same time, he amused

and entertained his audience; and none listened to him that were ever weary with his discourse. I have even known him to retain a congregation of willing and anxious listeners for many hours together, in the midst of cold or sunshine, rain or wind, while they were laughing at one moment and weeping the next. Even his most bitter enemies were generally overcome, if he could once get their ears.

Another disciple, one who was with him in his martyrdom in Carthage prison, thus sings of him:

The Seer, the Seer! Joseph the Seer!
O, how I love his memory dear!
The just and wise, the pure and free,
A father he was and is to me.
Let fiends now rage in their dark hour—
No matter, he is beyond their power.
He's free! he's free! the Prophet's free!
He is where he will ever be;
Beyond the reach of mobs and strife,
He rests unharmed in endless life;
His home's in the sky, he dwells with the Gods,
Far from the furious rage of mobs.
He died! he died for those he loved;
He reigns, he reigns in the realms above;
He waits with the just who have gone before,
To welcome the Saints to Zion's shore.

There are no known photographs of Joseph Smith. This image is apparently from Frederick Piercy, published with Joseph facing the opposite direction in James Linforth's 1855 *Route from Liverpool to Great Salt Lake Valley*, framed with flowers to provide a 3-D effect. Notice that the stereograph card (right) has the publisher's name in the left margin, the location of the company's photographic studios and assembly factories in the right margin, and on the bottom of the card the scene number and a short caption.

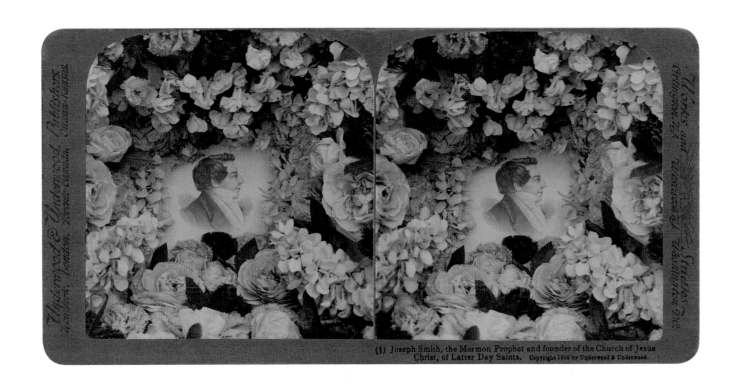

(1) Joseph Smith, the Mormon Prophet and founder of the Church of Jesus Christ, of Latter Day Saints. Copyright 1904 by Underwood & Underwood.

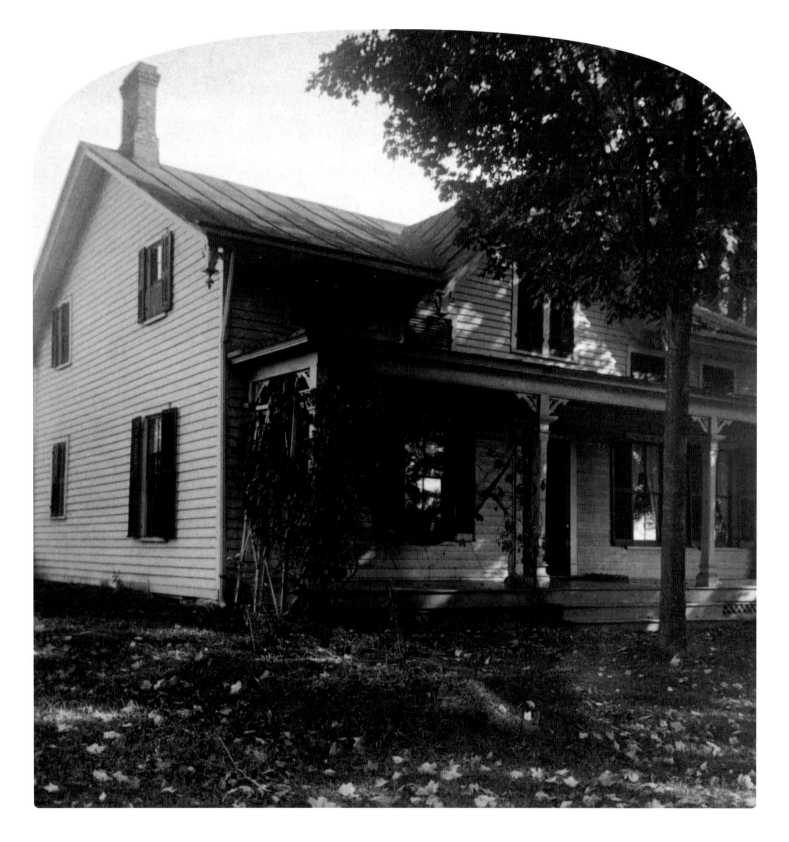

2 The Old Smith Homestead—Scene of Joseph Smith's First Visions and Revelations—near Palmyra, New York

A homely old-fashioned farm house is this Smith residence on the borders of the town of Palmyra, New York. Famous only because it sheltered through five eventful years the Prophet Joseph Smith. The Smith family, consisting at the time of Joseph Smith, Sen., his wife Lucy Mack Smith, five sons and two daughters, first appeared in Palmyra in 1815. The family had moved from the State of Vermont, where crop-failures for several years in succession had rendered their farming operations unproductive, notwithstanding their industry and providence. On arriving at Palmyra the Vermont farmer took counsel with his family, and succeeded by a united effort in purchasing, on the plan of yearly installments, one hundred acres of land, a part of the Everson estate, and on it erected first a log house which served as a temporary home while clearing their farm of timber and making their first few annual payments. Prosperity followed the industry of the family for a few years, and in the summer of 1824 they ventured upon the erection of a more comfortable home which is seen in stereograph No. 2. The house is on the left as you drive from Palmyra in the direction of Manchester, and faces west. In the view presented we are looking from the northwest and see the north end and west side or front of the house. The erection of this house was the especial labor of Alvin, the eldest son of the family, of whom the Prophet said in after years, "My brother Alvin was the handsomest, and most physically perfect man I have ever seen;" while his mother speaks of him as "a youth of singular goodness of disposition, kind and amiable." In the erection of this home the one great joy of Alvin's heart was the pleasant prospect of seeing his father and mother comfortable and happy in their old age. To the neighbors who watched the progress of the building he was known frequently to say: "I am going to have a nice pleasant room for father and mother to sit in, and everything arranged for their comfort. They shall not work any more as they have done." An utterance which breathes such filial love that it is not difficult to believe all his mother said of him. He was not destined, however, to see the fulfillment of his hopes. He was struck down in the midst of his joyous anticipations by the hand of death, and the family was prostrated with grief.

As soon as they recovered from this shock, however, they renewed their efforts to complete the house, and soon were comfortably settled in it. Here the fond mother had the pleasure of welcoming home the bride of her eldest living son, Hyrum. His wife she describes as "one of the most excellent of women," and one with whom she had great happiness. Here, also, with "all the pride and ambition in doing so that is common to mothers upon such occasions," she subsequently welcomed home the bride of her son Joseph. It was about the fireside of this old farm house that the Smith family gathered in the evenings of the long winter days and read the sacred scriptures; a circumstance which led some of their neighbors to say, "the Smiths held school at their home and used the Bible as their text book." Joseph, the Prophet, in the innocence and gladness of his youth, at that same fireside, both amused and instructed the family with his lively descriptions of the customs and manners of the Nephites, "their dress, mode of traveling, the animals upon which they rode, their cities, their buildings, with every particular; their mode of warfare, as also their religious worship. And all this he would do," says his mother, "with as much ease, seemingly, as if he had spent his whole life with them." To this old home the Prophet brought the sacred plates of the Book of Mormon. Here they were concealed in various parts of the house, to keep them from the sacrilegious hands of those who sought their destruction. Mobs gathered about the doorways and windows of this home, disturbing and annoying the inmates; watching an opportunity to purloin that which God had entrusted to the keeping of this family. It was here, after the translation of the Book of Mormon was completed, that Oliver Cowdery made from the original manuscript, the copy that was used by the printer at Palmyra. Each morning Hyrum Smith accompanied either by Oliver Cowdery or one of the members of the Smith family, trudged daily to Palmyra with the allotment of manuscript for the day's work, and back again in the evening with the proofs, until the great work of bringing forth this American volume of Scripture was accomplished.

Sorrow sometimes crossed the threshold of this home to chasten the hearts of the inmates. No sooner was the house finished than a Mr. Stoddard, the chief carpenter in its construction, offered to purchase it for fifteen hundred dollars. Failing of this he joined with others to rob the Smith family of the fruits of years of industry; for by misrepresentation of the character and intentions of the family to the agent in charge of the Everson estate, when but one more payment was due as a condition precedent to the securing of absolute title to

the property, this Mr. Stoddard and his partners purchased the farm and threw its owners into consternation. By persistent energy and activity on the part of all, however, the immediate danger of losing the home was averted. The money for final payment was borrowed, the Everson agent satisfied; but to accomplish this such obligations had to be entered into with those from whom the money was borrowed that the Smiths had virtually placed themselves at the mercy of a new landlord; and finally the time came when the home projected by Alvin and completed by the united industry of the whole family, had to be abandoned.

And so it happened that this old house known as the home of the Smiths, at Palmyra, is associated with some of the supremest joys and keenest sorrows of that remarkable family who built it. But if the true idea of a home, to paraphrase the words of a quaint American writer, includes something more than a place to live in; if it means a particular spot in which the mind is developed, the character trained, and the affections fed; if it supposes a chain of associations by which mute material forms are linked to certain states of thought and moods of feeling, so that our joys and sorrows, our struggles and triumphs, are chronicled on the walls of a house, the trunk of a tree, or the walks of a garden—in a word, if home is conceived of as a place sanctified by the commingling of joys and sorrows, then in the truest, noblest and best sense, this old house at Palmyra was a home to the Smiths; and, moreover, a typical, old-fashioned American home, such as cradled that noble race which founded the Great Republic of the Western World.

LDS apostle George Albert Smith purchased the Smith house in 1907 for $16,000, as part of a 100-acre farm. He sold it to the church nine years later for $1.00.

3 Cumorah Hill, where the Prophet received the Golden Plates or Records of Book of Mormon, near Palmyra, New York

The Hill Cumorah lies on the east side of the road between Manchester and the town of Palmyra, in Wayne county, New York, about four miles south of the latter place, and a scant two miles south of the old Smith homestead just described. By the people in and about Palmyra and Manchester it is called "Mormon Hill" or "Mormon Bible Hill," because it was here that the Prophet Joseph Smith, directed by the angel Moroni, found hidden in a stone box the golden plates of the Nephite record, called the Book of Mormon. By the Jaredites, the people whom the Book of Mormon represents as migrating from the Euphrates valley to America in very ancient times, this hill was called Ramah, but the Nephites who succeeded the Jaredites in the occupation of the country gave it the name of Cumorah, and it was about this prominent landmark in western New York that the Nephite nation was destroyed in a series of battles about the close of the fourth century A.D.

Approaching Cumorah from the north one is confronted by the bold front of the hill which rises quite abruptly from the common level of the surrounding country; and as the east and west slopes, as viewed from the north, seem about equal and regular, it looks from a distance as though it might be a large conical shaped mound. Ascending its steep north side to the summit dispels the illusion, for one finds that he has but climbed the abrupt north end of a range of hill, having its greatest extent from north to south, and which from its very narrow summit broadens and slopes gently to the southward until it sinks to the common level of the country. The east side of the hill is now plowed, but the west side is untouched by the husbandman, and about two or three hundred yards from the north end there is on the west side a small growth of young trees with here and there a decaying stump of a large tree to bear witness that the hill was once covered with a heavy growth of timber.

Undoubtedly Cumorah is the most distinct landmark in all that section of country, the highest hill and the most commanding in an extensive plain sloping northward filled with numerous hills and which, in the main, have their greatest extent, like Cumorah, from north to south; and also, like Cumorah, are generally highest at the north end. West of this notable hill the country is more open than on the south or east. The hills are fewer and the plain more extensive. Though the country south and east is broken and the numerous hills higher than on the west, yet such is the commanding height of Cumorah that the view is unobstructed for many miles. Some distance northward hills are thickly clustered. Between them and Cumorah is located the town of Palmyra, and beyond that, at the foot of the clustered hills referred to, runs what is now called

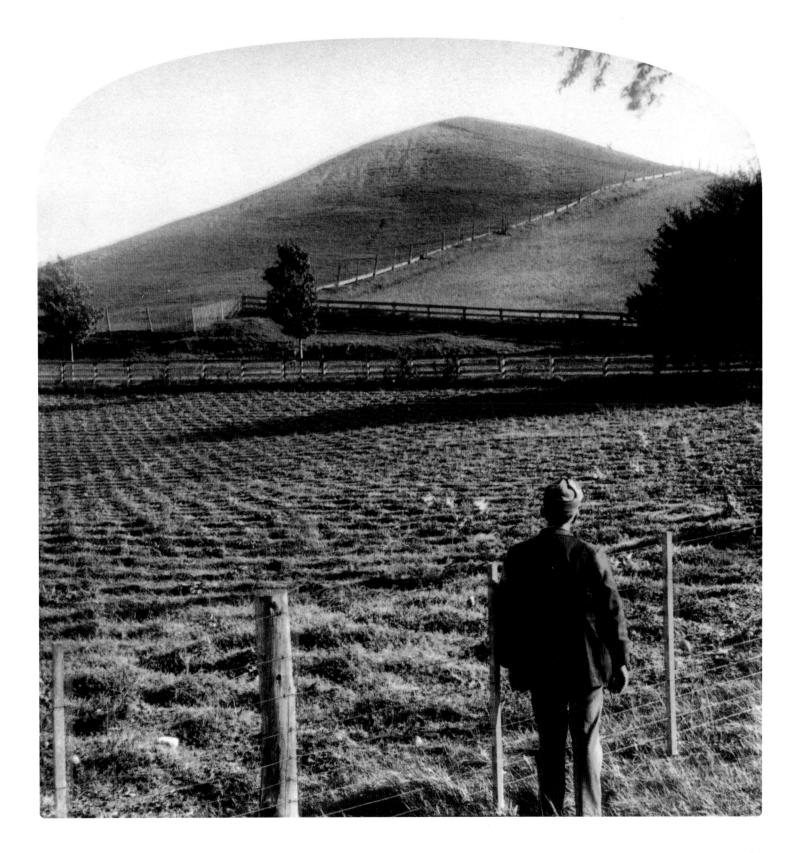

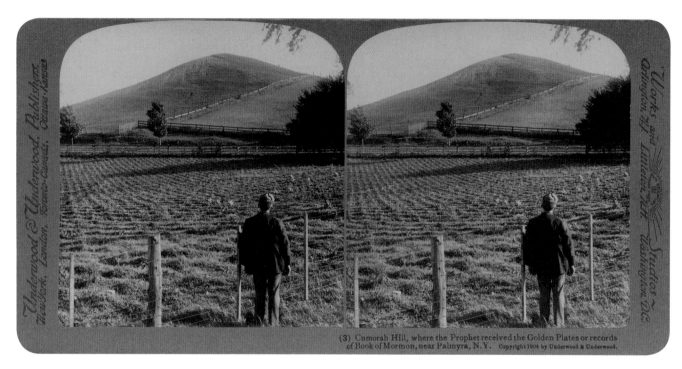

Canagrie creek, really one of the tributaries of the Clyde river into which it empties at no great distance. Such is the Hill Cumorah and its surroundings.

It was around this noted landmark that the last battles of the terrible internecine war which ended in the complete destruction of the Jaredite nation were fought, early in the sixth century B.C. Here, also, according to the Book of Mormon, the Nephite nation was destroyed, as already remarked, about the close of the fourth century A.D. But it is not as a monument which marks these ancient battlefields that Cumorah for us takes on its chief interest.

It will be known more especially to the present and future generations as the place where the golden plates of the Book of Mormon were discovered. During the night of the 21st of September, 1823, the angel Moroni appeared to Joseph Smith at the home of his father, already described, and made known to him the existence of this ancient record, and also the place where it was deposited. While the angel was conversing with the Prophet about the plates the vision of Joseph's mind was opened that he saw the place where the plates were deposited, and that so clearly and distinctly that he knew the place when he

visited it on the following day. While the existence of the plates was made known to the Prophet on the above date, he did not obtain possession of them until four years had passed. Meantime he met Moroni annually at Cumorah, and there received instructions concerning the work of the Lord in the last days; how it was to be brought forth, how established and governed.

The Nephite plates were found, according to Joseph Smith, "on the west side of this hill, not far from the top, under a stone of considerable size;" and as we are looking across the hill to the northeast, a little to the right of its summit, and a little way down the hill towards us, would be the point where the Book of Mormon was deposited. The stone box in which the record was concealed was formed by laying the stones together in some kind of cement. In the bottom were laid two stones crosswise and on these lay the plates, together with the "interpreters" or Urim and Thummim and breast plate. Following is the Prophet Joseph Smith's own description of the plates and the manner in which he translated them:

> These records were engraven on plates which had the appearance of gold, each plate was six inches wide and eight inches long, and not quite so thick as common tin. They were filled with engravings, in Egyptian characters, and bound together in a volume as the leaves of a book, with three rings running through the whole. The volume was something near six inches in thickness, a part of which was sealed. The characters on the unsealed part were small, and beautifully engraved. The whole book exhibited many marks of antiquity in its construction, and much skill in the art of engraving. With the record was found a curious instrument, which the ancients called "Urim and Thummim," which consisted of two transparent stones set in the rim of a bow fastened to a breast plate. Through the medium of the Urim and Thummim I translated the record by the gift and power of God.

The Hill Cumorah is a glacial morain about 110 feet high. In 1928 the LDS Church completed purchase of the hill. It is located three miles south of the Smith family farm.

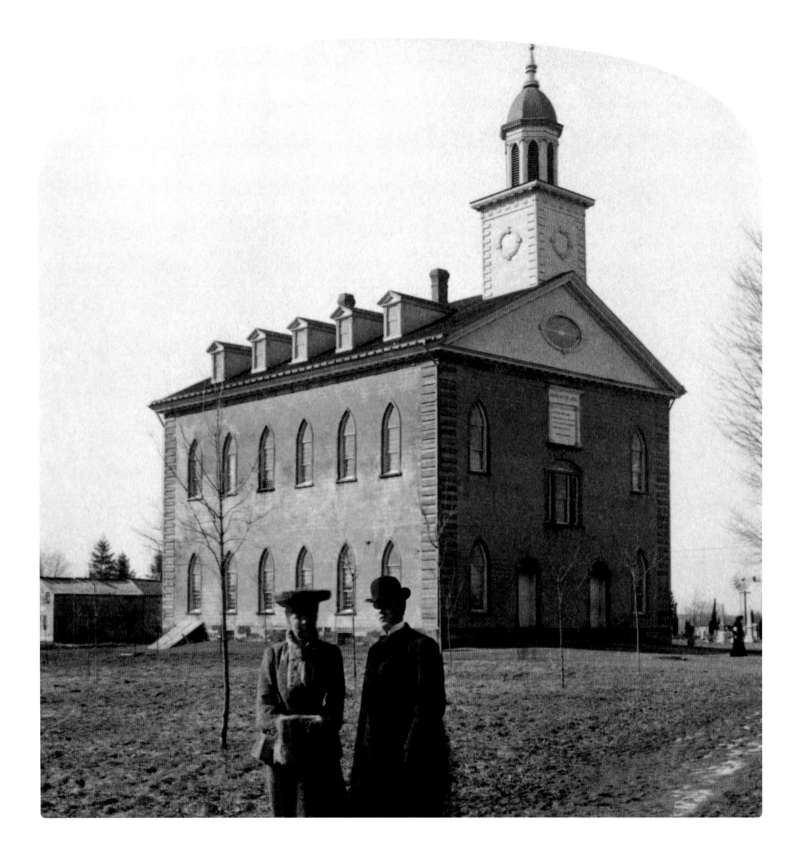

4 The Mormon Temple at Kirtland, Ohio, 59 x 79 feet—
cost $70,000, Dedicated March 27th, 1836

The Kirtland Temple was the first house of worship of any pretensions erected by the Latter-day Saints. It stands on the south bank of the Shagrin river on the crest of a commanding hill and faces east. It is about eighteen miles northeast of the city of Cleveland and some six miles south of the shores of Lake Erie, the blue waters of the lake being plainly visible on a clear day from the temple tower. It is a substantial structure of quarried sandstone except the corners, which are of hewn blockstone six inches by nine in thickness and breadth, four feet in length, and so set as to project slightly from the face of the walls which are plastered on the outside with a coat of most excellent cement and a skim coat of crushed glass, the uncracked or unbroken state of which, after some seventy years of exposure, proclaims the excellence of the workmanship of the contractors. The building is fifty-nine by seventy-nine feet outside measurement. The height of the walls, including the basement, is sixty feet to the square, and the height to the top of the spire is one hundred and twenty feet. It would be difficult to classify the Kirtland Temple under any particular style of architecture. It will be sufficient to say that its architecture is severely plain. It has twelve gothic windows on each side, and ten dormer windows projecting from the roof, five on each side. There are also four dormer windows in the east end, and a more pretentious arched window over the two doors which constitute the entrance to the building. There are two main halls in the temple, one above the other, besides the basement and five rooms in the attic. The doors in the east lead to a vestibule ten by thirty-five feet, at each end of which is a smaller vestibule ten by ten feet, from which extends a spiral stair way to the upper floors and the tower. The auditorium on the first floor is fifty-five by sixty-five feet. Through this auditorium as also through the one above there are eight wooden pillars which extend from stone butments in the basement to give support to floors and roof. The pulpits of this auditorium are quite unique. There are four tiers of them in each end; those in the west end were designed for the presiding officers in the Melchiesdek Priesthood; those in the east, for the officers of the Aaronic Priesthood, which are the two grand divisions of priesthood recognized in the Mormon hierarchy. The seats in the auditorium are generally described as box pews with adjustable backs, so that the pulpits in either end of the room could be faced by the auditors. Another unique arrangement about this auditorium was its division into four compartments by an arrangement of canvas curtains dropped from the ceiling so that on occasion four separate meetings could be conducted at the same time without the least interfering with each other. The upper auditorium was similarly arranged while the attic floor is divided into five rooms for class and committee purposes.

The corner stones of this structure were laid on the 23rd

of July, 1833, and the building was completed and ready for dedication on the 27th of March, 1836, so that it was some three years in course of construction. The cost of it has been variously estimated at from forty to seventy thousand dollars. Perhaps an equal distance from these two extremes would represent the true cost. How this structure came to be located in Ohio instead of in the state of New York, where Mormonism arose, cannot fail to be of interest.

Some eight or nine months after the Church had been organized at Fayette in Seneca county, New York, which organization, as before stated, took place on the 6th of April, 1830, the Saints in New York were commanded by revelation from God to assemble in Ohio. This is recognized as the first commandment given in this dispensation to the Saints to gather together. The commandment was doubtless given because of the spirit of bitter intolerance manifested against the Saints in New York, on the one hand and on the other Ohio promised a more flourishing field for the new faith. The Elders of the first mission organized by the Church, Oliver Cowdery, Parley P. Pratt, John Whitmer and Ziba Peterson, on their way westward along the southern shores of lake Erie, in the vicinity of Mentor and Kirtland Mills, found a people willing to listen to their testimony, and a considerable number joined the Church, including Sidney Rigdon, an influential minister of the sect of the Disciples (Campbellites), Edward Partridge, and others. In obedience to the above named commandment to gather in Ohio, the Prophet Joseph Smith with his family removed to this aforesaid section of Ohio, in January, 1831, and sometime later was followed by nearly all of the New York Saints. Here he remained for some time and large numbers were added to the Church. It soon became apparent that it was necessary for the Elders in the Church to be assembled together and more fully instructed in the doctrines of the new dispensation, and hence a school of the Elders, sometimes called a school of the Prophets, was commanded to be organized. For such organization a building was necessary, and consequently on the 4th of May, 1833, at a conference of High Priests held in Kirtland the necessity of building such a house was taken under advisement and a committee appointed to obtain subscriptions for the purpose of erecting a suitable building for the purposes contemplated. The outcome of the undertaking was the Kirtland Temple. During its dedication which continued through several days, beginning on the 27th of March, 1836, in order that all members of the Church within reach might partake of the privilege of the ceremonies, vast throngs crowded the building from day to day, and during the ceremonies conducted by the several quorums of the priesthood, the washing of feet, anointing with oil, prayer and sacramental ministrations, marvelous visions and the visitation of angels made it a pentecostal time for the Church of Christ in this new dispensation. Most important of all the heavenly ministrations were the great visions granted to the Prophet Joseph Smith and Oliver Cowdery which are thus described by them:

The veil was taken from our minds, and the eyes of our understanding were opened. We saw the Lord standing upon the breast work of the pulpit, before us, and under his feet was a paved work of pure gold in color like amber. His eyes

were as a flame of fire, the hair of his head was white like the pure snow, his countenance shone above the brightness of the sun, and his voice was as the sound of the rushing of great waters, even the voice of Jehovah, saying: I am the first and the last, I am he who liveth, I am he who was slain, I am your advocate with the Father. Behold, your sins are forgiven you, you are clean before me, therefore lift up your heads and rejoice, let the hearts of your brethren rejoice, and let the hearts of all my people rejoice, who have, with their might, built this house to my name, for behold, I have accepted this house, and my name shall be here, and I will manifest myself to my people in mercy in this house, yea, I will appear unto my servants, and speak unto them with mine own voice, if my people will keep my commandments, and do not pollute this holy house. Yea the hearts of thousands and tens of thousands shall greatly rejoice in consequence of the blessings which shall be poured out, and the endowment with which my servants have been endowed in this house; and the fame of this house shall spread to foreign lands, and this is the beginning of the blessing which shall be poured out upon the heads of my people. Even so. Amen.

After this vision closed, the heavens were again opened unto us, and Moses appeared before us, and committed unto us the keys of the gathering of Israel from the four parts of the earth, and the leading of the ten tribes from the land of the north.

After this, Elias appeared, and committed the dispensation of the gospel of Abraham, saying, that in us, and our seed, all generations after us should be blessed. After this vision had closed, another great and glorious vision burst upon us, for Elijah the prophet, who was taken to heaven without tasting death, stood before us, and said: Behold, the time has fully come, which was spoken of by the mouth of Malachi, testifying that he (Elijah) should be sent before the great and dreadful day of the Lord come, to turn the hearts of the fathers to the children, and the children to the fathers, lest the whole earth be smitten with a curse. Therefore the keys of this dispensation are committed into your hands, and by this ye may know that the great and dreadful day of the Lord is near, even at the doors.

After the dedication services were ended and some time had been spent in giving instructions to the Elders to more thoroughly prepare them for the work of the ministry, they went forth from Kirtland in great spiritual power preaching the gospel wherever they could find or make an opening, and the impetus given to the work vindicated the wisdom which directed the building of the Kirtland Temple, though it taxed the few Saints which then comprised the membership of the Church, and who in the main were not rich in the goods of this world, to their uttermost capacity; and much embarrassment was afterwards experienced by the Church in consequence of the indebtedness incurred in erecting this Temple.

The Kirtland Temple has been owned by the Reorganized LDS Church (now Community of Christ) since 1880. In 2007 a visitor center and museum were added to the property, now bounded on all sides by suburban sprawl and automobile traffic from Cleveland, the downtown area being about twenty miles to the west.

5 North over Temple Lot. Sight Marked by Mormon Prophecy for World's Greatest Temple, Independence, Mo.

From Kirtland, in the northeastern part of Ohio, to the site of the future chief Temple of Zion, shown in stereograph No. 5, is a mighty stride. Still, in the chronological order of events in the story of Mormonism, and consequently of our tour, the Temple Lot at Independence, Missouri, must now receive consideration. It is revealed in the Book of Mormon that a great city is to be founded in this western world that will be called Zion, a New Jerusalem. It is written that "Out of Zion shall go forth the law, and the word of the Lord from Jerusalem." Enlightened by the knowledge which comes from the Book of Mormon, the Latter-day Saints hold that two cities are here referred to by Isaiah—the capitals of the eastern and western hemispheres respectively. One from which the word of the Lord will yet go forth, and from the other His Law. The revelation of so great a truth to the early Elders of the Church was well-nigh overwhelming. Zion, the New Jerusalem, was a constant theme of thought and conversation among them. Where would be its location? What the character of its buildings? What the nature of its government? Would they be honored to lay its foundations? Would they and their children have an inheritance in the holy city? These questions were often discussed.

Meantime Joseph Smith and many of the New York Saints removed to Kirtland, Ohio; and here further knowledge was received on the subject of Zion. From Kirtland a number of Elders were to be sent into the western States to call upon the inhabitants to repent, and inasmuch as they would repent they were to build up churches unto the Lord, and later, with one heart and mind, were to gather up their riches and purchase an inheritance which should be appointed unto them. "And it shall be called the New Jerusalem" said the Lord, "a land of peace, a city of refuge, a place of safety for the Saints of the Most High God; and

the glory of the Lord shall be there, insomuch that the wicked will not come unto it, and it shall be called Zion. And it shall come to pass among the wicked that every man that will not take his sword against his neighbor, must needs flee unto Zion for safety." This revelation was given in March, 1831. The following June a conference of the Church assembled at which twenty-eight Elders were chosen to go in different directions through the western states two and two preaching by the way, "baptizing by water, and the laying on of hands by the water's side." These Elders were to meet in western Missouri and there learn the location of Zion. After many hardships in their journey a majority of these Elders, together with the Prophet Joseph Smith, met at Independence, Missouri. "When will Zion be built up in her glory," asked the Prophet of the Lord; "and where will Thy temple stand unto which all nations shall come in the last days?" The brethren were not long left in doubt upon this subject, for shortly afterwards a revelation was given in which the Lord declared that Missouri was the land which the Lord had appointed and consecrated for the gathering of His people. "Wherefore, this is the land of promise" said the Lord, "and the place for the city of Zion; and behold the place which is now called Independence is the center place, and the spot for the Temple is lying westward upon a lot which is not far from the court house." The Saints were commanded to purchase this land and that lying westward, to the extent of their ability, that they might obtain it as an "everlasting inheritance."

The site for the Temple in Zion is a scant half mile west of the court house in Independence, and is the crown of a hill. A gentle hill, of mild declivity, across which, in the stereograph, we are looking northward, and as now fenced off, is about an acre and a half in area, perhaps more. The only building in the enclosure is a small two-story frame building on the right, erected a few years ago by an association of people known as Hedrickites. The Temple site is doubtless the highest point of land in this region of country, and from it, especially when looking east and south, one gets a panoramic view of alternating fields and woodlands, of gently rolling hills and stretches of open plain, as grand as may be seen within the confines of the United States.

When the Temple site was first made known to Joseph Smith and his associates, it was covered with a heavy growth of timber, and here in one of God's first temples—a beautiful grove—on the 3rd of August, 1831, the Prophet and his associates assembled and dedicated the place as the chief Temple site of the future Zion. In the course of the simple but impressive ceremonies then conducted, the 87th Psalm was read:

> His foundation is the holy mountains.
> The Lord loveth the gates of Zion more than all the dwellings of Jacob.
> Glorious things are spoken of thee, O city of God.
> I will make mention of Rahab and Babylon to them that know me; behold Philistia and Tyre, with Ethiopia: this man was born there.
> And of Zion it shall be said, This and that man was born in her; and the Highest Himself shall establish her.
> The Lord shall count when he writeth up the people, that this man was born there.
> As well the singers as the players on instruments shall be there: all my springs (i.e. hopes) are in thee.

The Prophet then dedicated the spot where the Temple is to be built —a temple, by the way, on which the glory of God shall visibly rest; yea, God has declared it, saying: "Verily this generation shall not pass away until an house shall be built unto the Lord, and a cloud shall rest upon it, which cloud shall be even the glory of the Lord which shall fill the house; the sons of Moses and also the sons of Aaron shall offer an acceptable offering and sacrifice in the house of the Lord, which house shall be built unto the Lord in this generation, upon the consecrated spot as I have appointed."

An item of interest in connection with this theme is the fact that in the year 1904 the Church authorities at Salt Lake City, Utah, purchased a tract of land of some twenty-six acres formerly owned by the Church, and adjoining the lot shown in stereograph No 5.

In excavating the temple site in 1929, the Church of Christ (Temple Lot) found two stones marking the location of the intended future corners of the edifice. The stones are on display in their meeting house.

6 Ruins of jail where Joseph Smith, Hyrum Smith, and other Mormon Leaders were Imprisoned, Liberty, Mo.

Liberty Jail! At first glance how paradoxical the title. Liberty and prison are altogether antithetical and are supposed to have nothing in common, but when it is known that this particular prison is associated with liberty simply because it stands in a little Missouri town of that name—the county seat of Clay county, and about fifteen miles directly north of Independence—the seeming paradox vanishes. As will be seen by reference to the stereograph of this Mormon historical monument, Liberty prison is now fallen into ruins. The structure is built of rough dressed limestone, the surface of which is of a yellowish color. It faces east and is about two hundred yards from the court house. Its dimensions are about twenty by twenty-two feet and the walls are two feet thick. It had a heavy door in the east made strong and of considerable thickness by spiking inch oak planks together. In the south side there was a small opening a foot and a half square with strong iron bars, two inches apart, firmly imbedded in the stones of the wall. The contract for erecting this building was let in April, 1833, and in the December following the jail was completed. It cost the county six hundred dollars, Solomon Fry being the contractor.

It was within these gloomy walls that the Prophet Joseph Smith endured some of the most cruel sufferings that were crowded into his eventful life. For several months during the winter of 1838–9 he was imprisoned within the rude walls of this old structure awaiting a trial for offenses charged against himself and brethren during the troubles in upper Missouri in the fall of 1838. Those imprisoned with him were his brother Hyrum Smith, Lyman Wight, Caleb Baldwin, Alexander McRae and Sidney Rigdon; but the last named prisoner was admitted to bail after a short time of imprisonment, owing to the delicate state of his health.

The rise of persecution against: the Latter-day Saints in Missouri, which culminated in the expulsion of upwards of twelve hundred of them from their homes in Jackson county, in the winter of 1833; as also their subsequent settlement in several counties north of the Missouri river in 1836, together with the final expulsion of some fifteen thousand of the Saints from the confines of Missouri, in

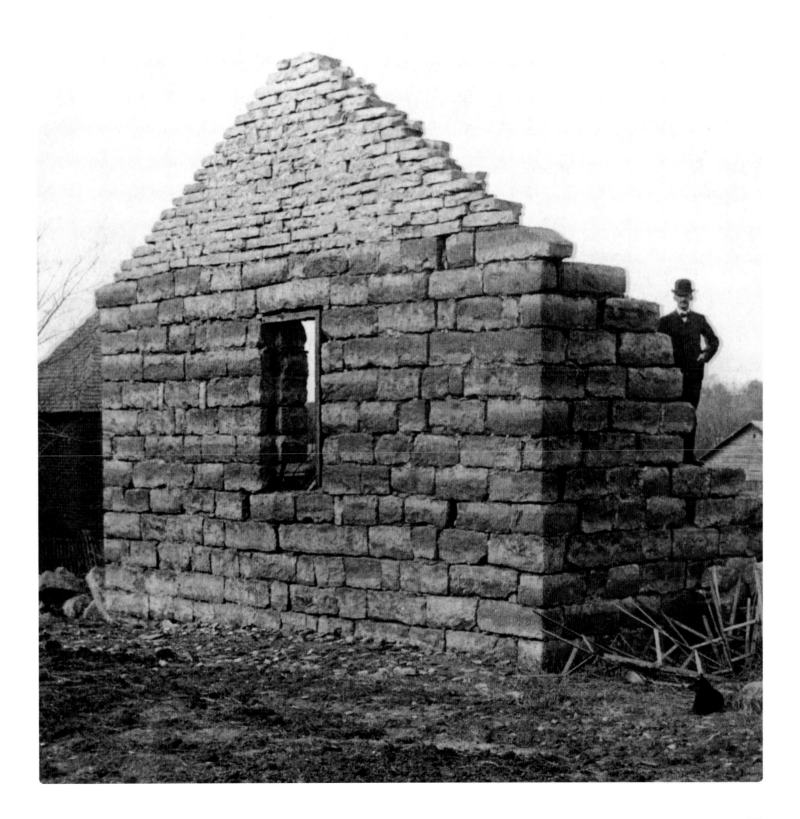

1838, under the exterminating order of the governor of the state, Lilburn W. Boggs, and executed by the state militia, are circumstances which belong rather to the domain of history than to this booklet. It will be sufficient here to say that the measures taken by the Saints for self-protection were construed into acts of aggressive warfare; and acts of self-defense were made criminal. It was for his connection with these measures of self-protection and self-defense that the Prophet and his associates were arraigned before courts where well known mobocrats sat as judges, and imprisoned these men to await the slow process of courts reluctant to bring them to trial lest the exposure of the proceedings in upper Missouri would bring reproach upon the state. We are concerned here, however, only with Liberty jail and the Prophet's life within its walls. His suffering was great and went far beyond the irritation which comes to active spirits when confined, the filthy and unwholesome food and the petty tyranny of unfriendly guards. The Prophet could not forget that while he himself was compelled to endure this enforced inactivity his own family and the entire Church, stripped of their earthly possessions, were being driven from the state at an inclement season of the year under circumstances of extreme cruelty. It was reflecting upon these conditions which wrung from him the soul-cry with which one of his revelations opens:—

O God! where are thou? And where is the pavilion that covereth thy hiding place? How long shall thy hand be stayed, and thine eye, yea thy pure eye, behold from the eternal heavens, the wrongs of thy people, and of thy servants, and thine ear be penetrated with their cries? Yea, O Lord, how long shall they suffer these wrongs and unlawful oppressions, before thine heart shall be softened towards them, and thy bowels be moved with compassion towards them?

To which the Lord made answer:

My son, peace be unto thy soul; thine adversity and thine afflictions shall be but a small moment; and then, if thou endure it well, God shall exalt thee on high; thou shalt triumph over all thy foes; thy friends do stand by thee, and they shall hail thee again, with warm hearts and friendly hands; thou art not yet as Job; thy friends do not contend against thee, neither charge thee with transgression, as they did Job; and they who do charge thee with transgression, their hope shall be blasted, and their prospects shall melt away as the hoar frost melteth before the burning rays of the rising sun. ... The ends of the earth shall enquire after thy name, and fools shall have thee in derision, and hell shall rage against thee, while the pure in heart, and the wise, and the noble, and the virtuous, shall seek counsel, and authority, and blessings

constantly from under thy hand, and thy people shall never be turned against thee by the testimony of traitors.

In the foregoing may be observed a prophecy which has met with remarkable fulfillment—the Prophet's people have never been turned against him by the testimony of traitors, however determined they may have been in such efforts.

It was not all gloom in Liberty prison either[,] during the time the Prophet and his brethren occupied it. As in all cases where the servants of God are imprisoned, the sweet and peaceful influences of the Holy Spirit were enjoyed. Within those gloomy prison walls some important revelations were received; petitions and remonstrances drafted, and letters of counsel and direction written to the Saints by the Prophet and his associates. Friends visited them from time to time, to assure the Prophet of their esteem and confidence. The wives of some of the prisoners, including the Prophet's, visited them to enquire of their welfare and take their leave of them before departing from the state.

The Prophet and his brethren having no confidence in the integrity of the courts in Missouri, and conscious of their own innocence, made several efforts to escape from Liberty jail, but without success. In April the prisoners were taken to Daviess county for trial, but finding Judge Thomas C. Birch on the bench, a man who had been connected with the court martial which had condemned the prisoners to be shot in the public square at Far West, but a few months before, they asked for a change of venue to Marion county. This was denied, but one was given them to Boone county. Judge Birch made out the mitimus without date, name or place[;] and the prisoners enroute for the next place of trial, with the connivance of their guards, made their escape, and ten days later arrived among their friends, who meantime had gathered to the city of Quincy and vicinity, in Illinois.

It may be true that prisons, like chains, survive the captives they enthrall; but in this instance the prison does not survive the work of its most illustrious captives; for while the prison hastens to its ruin, the work for which these Mormon prisoners stood, flourishes in a mightier strength than it ever knew in Missouri.

The Liberty Jail was converted to an ice house in the 1850s, but by 1888 it had become a ruin, later adapted as the basement of a home. The LDS Church purchased the site in 1939, and a museum containing a partial reconstruction of the jail was dedicated in 1963.

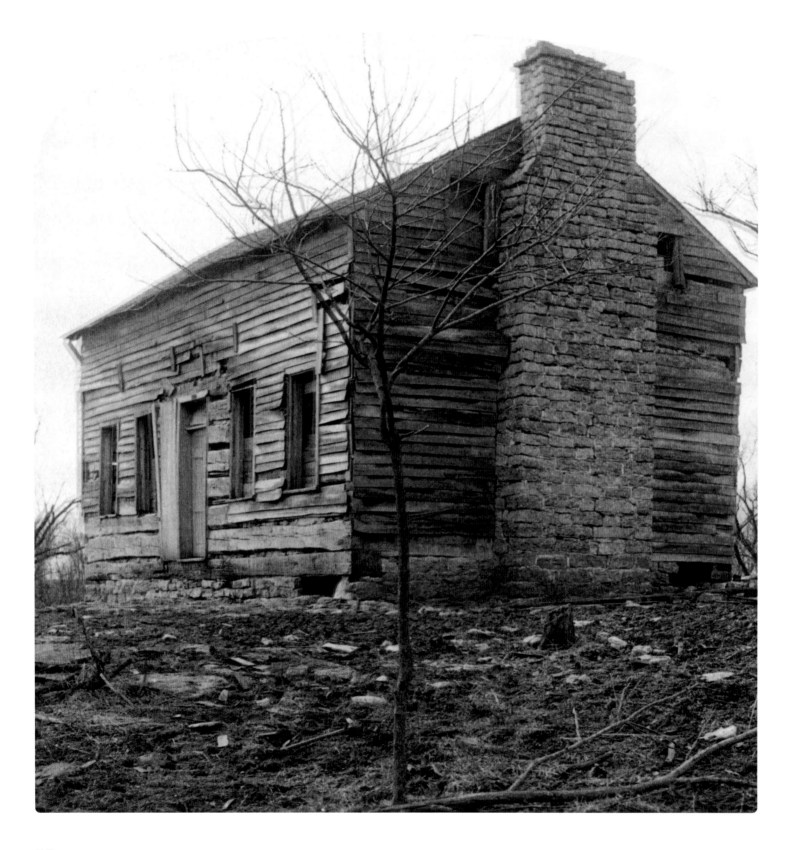

A 3-D TOUR OF LATTER-DAY SAINT HISTORY

7 Apostle Lyman Wight's House at Adam–ondi–Ahman, near Gallatin, Daviess Co., Mo.

A typical old Missouri home, of fifty years ago, is the house of Lyman Wight at "Adam-ondi-Ahman," located on the north bank of the Grand river in Daviess county. It is about fifty miles northeast of the town of Liberty, where is located our last view. The house was built in the spring of 1838 for Lyman Wight, at that time a prominent and valiant Elder in the Church, and subsequently made one of the Twelve Apostles. He was a man of great force of character, possessed an absolutely fearless spirit which gave almost an air of desperation to his conduct. He was strong in his friendships, and especially devoted to the Prophet Joseph Smith. He took an active part in all the defensive measures adopted to secure the safety of the Saints in Missouri, and his name was a terror to the mobocrats in upper Missouri during the troublous times of 1837–8.

His old homestead is shown in stereograph No. 7. It is of interest chiefly because it was the place where Joseph Smith frequently gathered his brethren about him in councils in those dark days of Missouri mob violence; and also because of its proximity to Adam–ondi–Ahman. It must be explained that Adam–ondi–Ahman is the name of an old altar that was somewhat after the fashion of those found in ancient mounds of North America, and called "Altar Mounds" though this altar was not covered by a mound. When the Prophet first visited this locality in May, 1838, a number of families of the Saints had been living there several months and called their settlement "Spring Hill," but the Prophet declared that it should be named Adam–ondi–Ahman as the Lord had revealed it to him that this was the place where Adam, the Ancient of Days, spoken of by Daniel the prophet (Daniel VII), should come to visit his people. It will be seen, therefore, that this place in the Grand river valley is of very great importance in the eyes of those who have faith in Mormonism, and justifies the following description and historical account of it.

Adam–ondi–Ahman, or Diahman, as it is familiarly known to the Saints, is located on the north bank of Grand river. It is situated, in fact, in a sharp bend of that stream. The river comes sweeping down from the northwest, and here makes a sudden turn and runs in a meandering course to the northeast for some two or three miles, when it as suddenly makes another bend and flows again to the southeast. Grand river is a stream that has worn a deep channel for itself, and left its banks precipitous; but at Diahman that is only true of the south bank. The stream, as it rushes from the northwest, struck the high prairie land which at this point contains beds of limestone, and not being able to cut its way through, it veered off to the northeast, and left that height of land standing like palisades which rise very abruptly from the stream to a height of from fifty to seventy-five feet; but the summit of these bluffs is the common level of the high rolling prairie, extending off in the direction of Far West. The bluffs on the north bank recede some distance from the stream, so that the river bottom at this point widens out to a small valley. The bluffs on the north bank of the river are by no means as steep as those on the south, and are covered with a light growth of timber. A ridge runs out from the main line of the bluffs into the river bottom some two or three hundred yards, approaching the stream at the point where the bend of the river is made. The termination of the bluff is quite abrupt, and overlooks a considerable portion of the river bottom. On the brow of the bluff stood the old stone altar, and near the foot of it was built the house of Lyman Wight, When the

altar was first discovered, according to those who visited it frequently, it was about sixteen feet long, by nine or ten feet wide, having its greatest extent north and south. The height of the altar at each end was some two and a half feet, gradually rising higher to the centre, which was between four and five feet high—the whole surface being crowning. Such was the altar at Diahman when the Mormons found it. Now, however, it is thrown down, and nothing but a mound of crumbling stones mixed with soil, and a few reddish boulders mark the spot which is doubtless rich in historic events. It was at this altar, according to the testimony of Joseph Smith, that the patriarchs associated with Adam and his company, assembled to worship their God. Here their evening and morning prayers ascended to heaven with the smoke of the burning sacrifice, and here angels instructed them in heavenly truths.

North of the ridge on which the ruins of the altar are found, and running parallel with it, is another ridge, separated from the first by a depression varying in width from fifty to a hundred yards. This small valley with the larger one through which flows Grand river, is the valley of Adam–ondi–Ahman. Three years previous to the death of Adam, declares one of the Prophet Joseph's revelations, the Patriarchs Seth, Enos, Cainan, Mahalaleel, Jared, Enoch and Methuselah, together with all their righteous posterity, were assembled in this valley we have described, and their common father, Adam, gave them his last blessing. And even as he blessed them, the heavens were opened, and the Lord appeared, and in the presence of God, the children of Adam arose and blessed him, and called him Michael, the Prince, the Archangel. The Lord also blessed Adam, saying: "I have set thee to be the head—a multitude of nations shall come of thee, and thou art a prince over them forever." So great was the influence of this double blessing upon Adam, that, though bowed down with age, under the outpouring of the Spirit of God, he predicted what should befall his posterity to their latest generations.

Interest in the valley of Diahman is not confined to the past, however; it is connected with the future also; for it is in this same valley, as the Saints believe, that the Ancient of Days will come and meet with his posterity as described by the prophet Daniel: "When thousand thousands shall minister to him, and ten thousand times ten thousand shall stand before him." Here is where the books shall be opened and the judgment shall sit. Here, too, the Son of Man shall appear in the clouds of heaven to this vast multitude, and coming to the Ancient of Days shall give to him dominion and glory, and issue a decree that all people, nations and languages shall serve and obey him; and his dominion shall be everlasting, and his kingdom one that shall never be destroyed. Such were the scenes of the past enacted in the Valley of Diahman; such are to be the splendid scenes enacted there in the future. Meantime this old and fast decaying house of Lyman Wight's, shown in stereograph No. 7, is the only monument that now marks a spot sacred to the Latter-day Saints.

Lyman Wight's second home in the Grand River Valley (Adam-ondi-Ahman) remained unfinished after Mormons were driven away in 1838. It was remodeled and used as a farm house but abandoned again by 1904.

NAUVOO

Scenes in the city of Nauvoo next occupy our attention. Nauvoo is the name which the Saints gave to their city on the banks of the Mississippi. It is a Hebrew word meaning "beautiful, and carrying with it the idea of rest." The location of the city is beautiful. No sooner does one come in view of it than he exclaims, "It is rightly named." The city, or at least the marred remains of it, stands on a bold point around which sweeps the placid, yet majestic "Father of Waters"—the Mississippi. The city is at least half encircled by that noble stream. From the bank of the river the ground rises gradually for at least a mile, when it reaches the common level of the prairies, which stretch out to the eastward, further than the eye can reach, in a beautiful undulating surface, once covered by a luxuriant growth of natural grasses and wild flowers, relieved here and there by patches of timber; but now checkered with meadows, and fields of waving corn. Opposite Nauvoo, on the west bank of the river, the bluffs rise rather abruptly, almost from the water's edge, and are covered, for the most part, with a fine growth of timber. Nestling at the foot of one of the highest of these bluffs, and immediately on the bank of the river is the little village of Montrose. Back of the bluffs before mentioned, rolls off the alternate woodlands and fields of Iowa. Between Montrose and Nauvoo, and perhaps two-thirds of the distance across the river from the Illinois side, is an island, from three-fourths of a mile to a mile in length, and from fifty to one or two hundred yards in width, having its greatest extent north and south.

Nauvoo is just at the head of what are called the Des Moines Rapids, in the extreme western portion of Hancock county, about 190 miles above St. Louis. Such is the location of Nauvoo and its immediate surroundings. Before the lands in this vicinity were purchased by the Saints, the little settlement, consisting of one stone house, three brick houses and two block houses, was called Commerce. The place is described by the Prophet Joseph as being literally a wilderness. "The land" he says, "was mostly covered with trees and bushes, and much of it was so wet that it was with the utmost difficulty a footman could go through and totally impossible for teams. Commerce was unhealthful. Very few lived there, but believing that it might become a healthful place by the blessing of heaven to the Saints, and no more eligible place presenting itself, I considered it wisdom to make an attempt to build up a city."

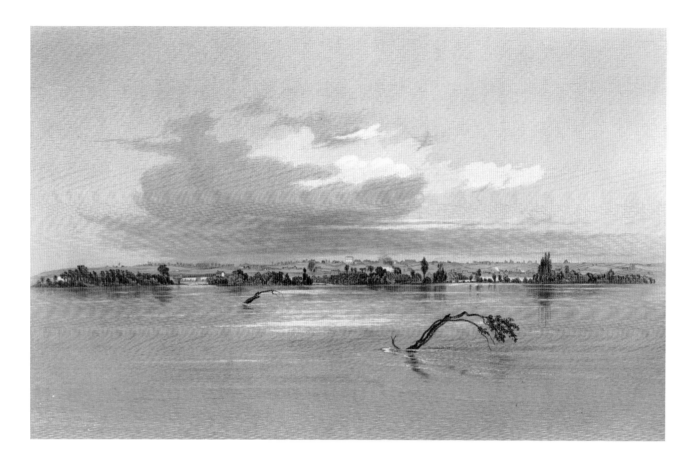

Nauvoo was incorporated by act of the legislature of Illinois, on the fourteenth of December, 1840. The charter granted on that date described the boundaries of the city, but gave to the citizens—whom it created a body corporate and politic—the right to extend the area of the city whenever any tract of land adjoining should have been laid out into town lots and recorded according to law. The city council was to consist of a mayor, four aldermen and nine councilors, to be elected by the qualified voters of the city. The first Monday in February, 1841, was appointed for the first election of officers.

The charter granted to the citizens of Nauvoo the most plenary powers in the management of their local affairs. Indeed, about the only limit placed upon their powers was, that they do nothing inconsistent with the constitution of the United States, and the state constitution of Illinois. But inside of those lines they were all powerful to make and execute such ordinances as in the wisdom of the city council were necessary for the peace, good order, and general welfare of the city. It afterwards became a question in the state as to whether or not powers too great had not been granted to the city government. The leading men of the state, however, appeared not only willing but anxious to grant the privileges of this city government to the Saints. An incident connecting Abraham Lincoln

with the passage of this charter may not be without interest. The State of Illinois was at that time divided into two political parties, Whigs and Democrats. Both parties were friendly to the Saints, who considered themselves equally bound to both parties for acts of kindness. Lincoln was a Whig, and in the November election his name was on the State electoral ticket as a Whig candidate for the State legislature. But many of the people of Nauvoo, wishing to divide their vote, and to show a kindness to the Democrats, erased the name of Lincoln, and substituted that of Ralston, a Democrat. It was with no ill feeling, however, towards Mr. Lincoln that this was done, and when the vote was called on the final passage of the Nauvoo charter, he had the magnanimity to vote for it; and congratulated John C. Bennett (then a prominent Mormon having the charter in hand before the legislature) on his success in securing its enactment.

The Saints rejoiced in the prospects of liberty secured

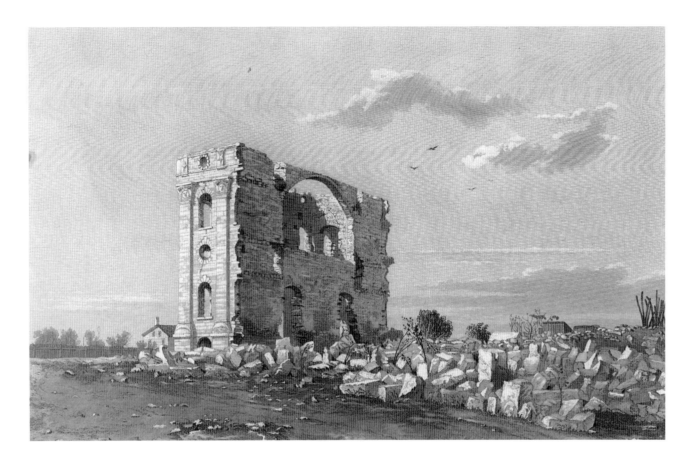

to them by their city government, and of it Joseph said: "I concocted it for the salvation of the Church, and on principles so broad, that every honest man might dwell secure under its protecting influence, without distinction of sect or party." An inspection of the charter will bear out this opinion of it, for while it was "concocted for the salvation of the 'Church" it by no means secured that salvation by trespassing upon the rights of others, but by recognizing the rights of the Saints to be equal to the rights of other citizens. Nor was it intended that Nauvoo should be an exclusive city for people of the Mormon faith; on the contrary, all worthy people were invited to come and assist to build it up and partake of its liberty and anticipated prosperity. An official proclamation by the First Presidency of the Church, contains the following passage: "We wish it likewise to be distinctly understood, that we claim no privileges but what we feel cheerfully disposed to share with our fellow-citizens of every denomination, and every sentiment of religion; and therefore say, that so far from being restricted to our own faith, let all those who desire to locate in this place (Nauvoo) or the vicinity, come, and we will hail them as citizens and friends, and shall feel it not only a duty, but a privilege to reciprocate the kindness we have received from the benevolent and kind-hearted citizens of the State of Illinois."

The Prophet's "attempt" to build up a city on these principles was successful; for in the course of four or five years the city of Nauvoo arose out of the wilderness and bogs of Commerce and became a prosperous manufacturing and commercial city of upwards of twenty thousand inhabitants, surrounded by as beautiful a farming country as may be found anywhere in the Mississippi valley; and it has associated with its rise and fall many stirring historical events, both of local and world-wide fame.

These images are Frederick Piercy's 1853 engravings, "View from the River" and "Ruins of the Temple in Nauvoo," in *Route from Liverpool to Great Salt Lake Valley*.

8 Looking east along Mulholland Street, from south side of Temple Block, Nauvoo, Illinois

The first view within the city of Nauvoo, finds us standing on Mulholland Street looking directly east from the south side of the block on which the Temple stood. Mulholland Street runs directly through the center of the city east and west. It was named after James Mulholland, who for a time was the private secretary to the Prophet Joseph. In the organization affected for the purchase of lands in Commerce and vicinity in 1839, Joseph Smith was made treasurer and James Mulholland sub-treasurer. Mulholland was active in assisting to settle the Saints at Commerce, but he died on the 3rd of November, 1839, at the age of thirty-five. The Prophet speaks of him as a man of "fine education, a faithful scribe and Elder in the Church."

Mulholland street is now the main business thoroughfare of Nauvoo. In the foreground on the right is the Ocher building; and on the left is the Reimbold building, on the corner of Woodruff and Mulholland Streets. The Nauvoo post office is located in this building, fronting Mulholland Street. In the same block, stands the old Nauvoo Expositor building, before which was enacted one of the most exciting scenes connected with the history of Nauvoo, viz. the destruction of the Expositor press and scattering of its type in the street, by order of the city council, which action did so much to influence the public mind against the citizens of Nauvoo in the fateful year of 1844. The whole business center of Nauvoo at present is seen in this one view. How different it might have been had the Saints been permitted to have remained in Nauvoo, the beautiful, the city of Joseph!

9 The temple of Nauvoo, Illinois, 88 x 128 feet, corner stone laid April 6, 1841; burned November 10, 1848

Moving westward one half block along Mulholland Street, thence north one half block on Woodruff Street, and we front the Nauvoo Temple site, where once stood the magnificent building shown in stereograph No. 9. The building rose sixty-five feet from the ground to the roof. It was of light gray cut limestone, and stood eighty-eight by one hundred and twenty-eight feet in dimensions. It had a basement, two main stories and attic rooms in the squared west end. In the latter also was inscribed in golden letters the following:

THE

HOUSE OF THE LORD,

BUILT BY THE CHURCH OF

JESUS CHRIST

OF LATTER DAY SAINTS

HOLINESS TO THE LORD

The walls were strengthened by thirty cut stone pilasters, nine on each side and six at each end. The bases of these pilasters were crescent moons, the capitals, two and one-half feet broad, were suns in which were outlined the human face surmounted by two hands holding trumpets. There were four tiers of windows, two gothic, two circular. The main entrance was through three arched open passages to a vestibule whence doors lead into the lower court, and on the right and left of the vestibule were the stairways leading to the upper court. In the basement was located the baptismal font resting on twelve oxen, life size, and here baptisms were performed both for the living and the dead, in accordance with Mormon doctrine upon that subject. The whole structure is supposed to have cost upwards of one million dollars.

The corner stones of the Temple were laid in the midst of much pomp and ceremony on the 6th of April, 1841. In those days of our republic much pride was taken in the militia of the respective states, the citizen soldiery composing it being the chief reliance of the respective states and the nation for whatever of offensive or defensive warfare might be necessary. Consequently in many merely civic and even religious or fraternal society ceremonies local militia companies were used to give an air of splendor to the occasion. Hence it came to pass that

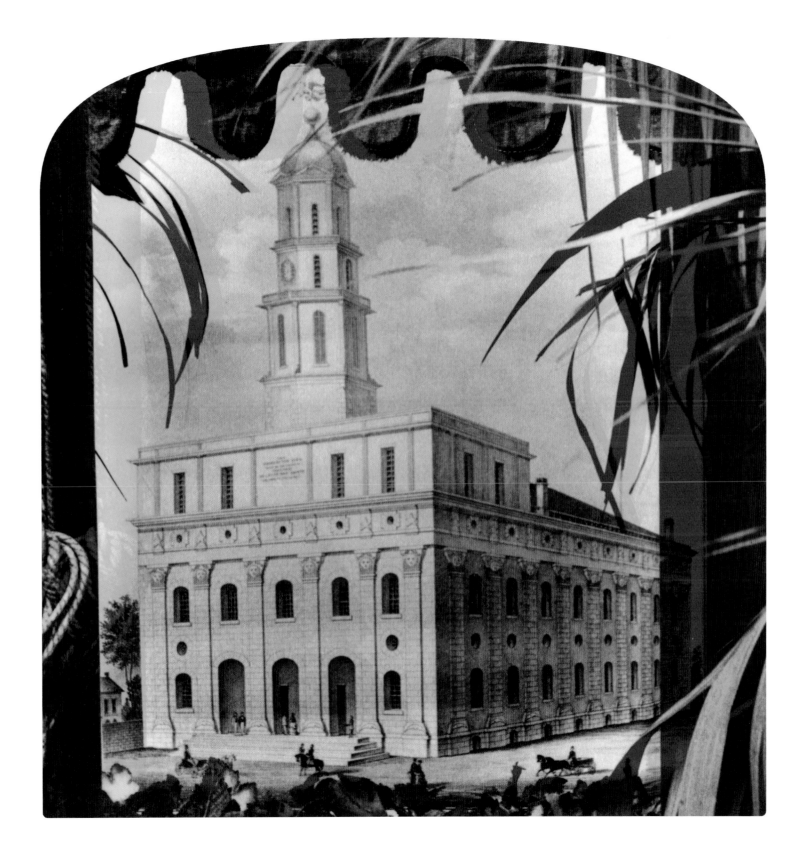

when the corner stones of the Nauvoo Temple were laid the militia organizations of the city took a prominent part, their evolutions, the firing of musketry and the booming of cannon adding magnificence to the ceremonies. Joseph Smith laid the chief., that is to say, the southeast, corner stone; and the Prophet as it settled in its place said to the multitudes "This principal corner stone in representation of the First Presidency is now duly laid in honor of the Great God."

Four years, one month and eighteen days from that time—the Prophet Joseph Smith meantime having suffered martyrdom—the capstone of the Temple was laid by President Brigham Young in the midst of playing bands and shouts of hosanna. By October following the structure was so far completed that meetings were held within its walls. The first being held October 5th at which about five thousand people were in attendance, and on that date the Temple was, so far as it was completed, dedicated to the Lord as a monument of the liberality, fidelity and faith of the Saints. The meetings continued through the following three days, the occasion being the general conference of the Church, and the only general conference held within the Temple's walls. During the winter of 1845–6 very many of the Saints were attending to sacred ordinances of the gospel within the Temple upon which the people never ceased to labor, notwithstanding it was now evident that Nauvoo and the Temple would have to be abandoned by them in the spring. In the evening of the 30th of April, 1846—the main body of the citizens of Nauvoo in the meantime having crossed the Mississippi and started upon their wonderful journey through the wilderness in the direction of the Rocky Mountains—Elders Orson Hyde and Wilford Woodruff of the Apostles, assisted by several other prominent Elders of the Church, secretly dedicated the Temple, and on the day following, May 1st, the Temple was publicly dedicated, after which the officiating Elders joined their people in their removal westward.

The Temple was always an object of envy to the enemies of the Church, and so long as it stood unimpaired there were always fears entertained that it would be a strong temptation to the Saints to return to so magnificent a shrine. Hence in November, 1848, an incendiary, it is said, was employed to fire it, with the result that all that could be destroyed by fire was destroyed. The walls, however, being well built, remained standing, and subsequently the Icarians, a French socialistic society who succeeded the Saints in the occupancy of Nauvoo, prepared to put on the roof and reconstruct the interior. Before they could do so, however, a tornado (May 27, 1850), hurled down the north wall and left the

sacred structure in ruins. In time the stones were hauled away to be used in the erection of other buildings, until now nothing remains of the Temple, erected at so great a sacrifice on the part of the Saints, and in the midst of their poverty and when threatened on every hand by mob violence. They completed it, however, and left it a dedicated monument of their patience and their faithfulness.

Turning now from facing the Temple and looking westward one finds that it stood upon the highest point of land hereabouts, overlooking the grand sweep of the Mississippi as it majestically moves around the point of land extending westward around the bluff on which the Temple had been erected. The island in the river, the village of Montrose and the river bluffs for miles both up and down the stream may be seen in their magnificence. Surely these Mormon leaders chose a magnificent site for the second Temple their people built.

Lithographed in 1890 by Chester B. Dike, this image of the Nauvoo Temple was apparently displayed in the lobby of the Nauvoo State Bank for more than a hundred years.

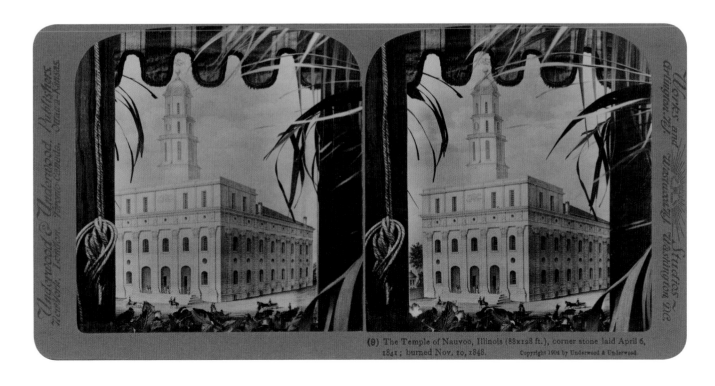

(8) The Temple of Nauvoo, Illinois (88x128 ft.), corner stone laid April 6, 1841; burned Nov. 10, 1848. Copyright 1904 by Underwood & Underwood.

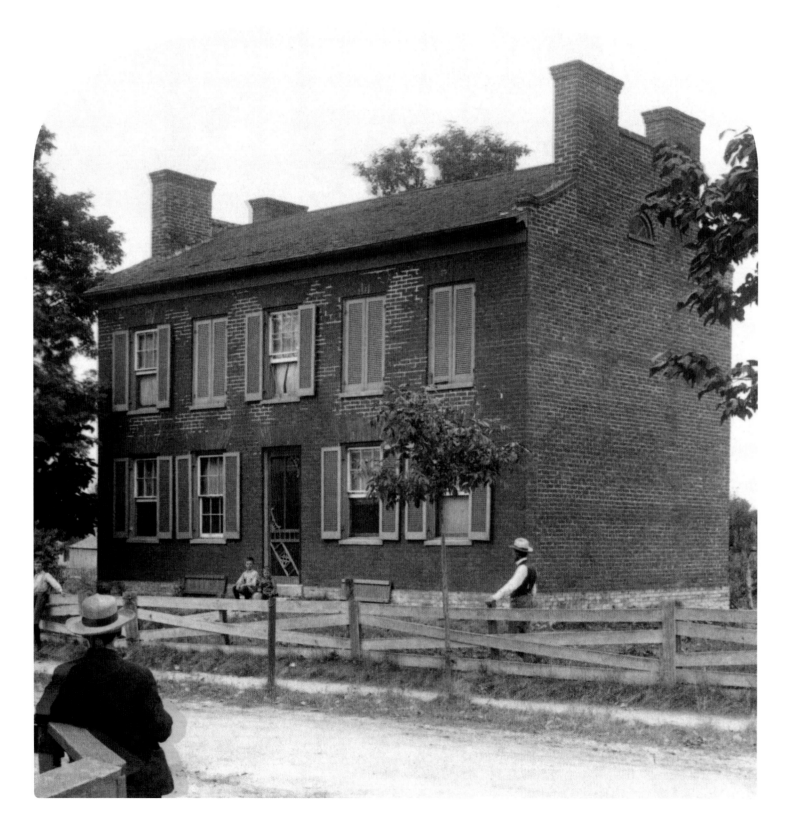

Stereograph No. 10 represents the Nauvoo home of the late President Wilford Woodruff on the corner of Durphey and Hotchkiss Streets. The house is a severely plain two-story, brick building somewhat after the old Pennsylvania Dutch style of homes, and faces east. In the stereograph we are looking southwest. The home was erected by Elder Woodruff after his return from his mission to England in 1841 or 1842, when Nauvoo was rapidly developing into one of the foremost cities of the west. It seems scarcely credible that this old home should outlast the earthly career of the man who built it. In a way the building is typical of the man who erected it, simple, modest, plain; yet among the sons of men who have figured in the latter-day dispensation of the gospel ushered in through the labors of the Prophet Joseph Smith, there has been no more lovable personality than Wilford Woodruff. He who lived in this plain old house at Nauvoo became one of the first pioneers of American history. He assisted not only in founding the great State of Utah, but in founding civilization itself in our whole intermountain region of the west. For eleven years, 1887 to 1898 he was the President of the Church of Jesus Christ of Latter-day Saints, and when he died he was held in the highest esteem not only by the members of his own Church, but by the citizens of Utah irrespective of Church affiliations.

The fourth LDS president, Wilford Woodruff, completed his Nauvoo home in the summer of 1844 and lived there until he departed for the West in 1846.

A short distance southwest of the Woodruff residence is the home of the late President Lorenzo Snow. It is a pretentious and well preserved structure of two stories, facing east on Carlin Street. In the stereograph we are looking at the building from the southeast. It will be seen that the Snow residence was a spacious, substantial building like many other residences of prominent Church leaders in Nauvoo that had to be sacrificed at the time of the exodus in 1846. In all the subsequent years of the life of Lorenzo Snow, however, in all that he has written, and that has been written about him, I can learn of no reference being made to his sacrifice in the way of regret or lamentation.

The late President Snow, whose Nauvoo home is before us, was a graduate of Oberlin College, Ohio. He was a man of refinement and broad intelligence. Like President Woodruff he was a pioneer of the inter-mountain west; but also enjoyed the privilege of extensive travel in Europe and the Orient. He became the President of the Mormon Church soon after the demise of President Woodruff in 1898, a position he held for about four years; and although his administration was brief, and the opportunities afforded by the position came to him late in life, yet his administration was remarkable for its vigor and achievements. He, too, won the confidence and esteem of both Mormon and non-Mormon citizens of the inter-mountain states, and was esteemed as a man of keen intelligence, of upright character, and commanding influence.

This duplex housed Nathaniel Ashby and Erastus Snow and their families. Erastus was a distant relative of Lorenzo Snow. It is uncertain whether the fifth LDS president, Lorenzo Snow, lived here. As a schoolteacher, he more likely boarded in rented rooms.

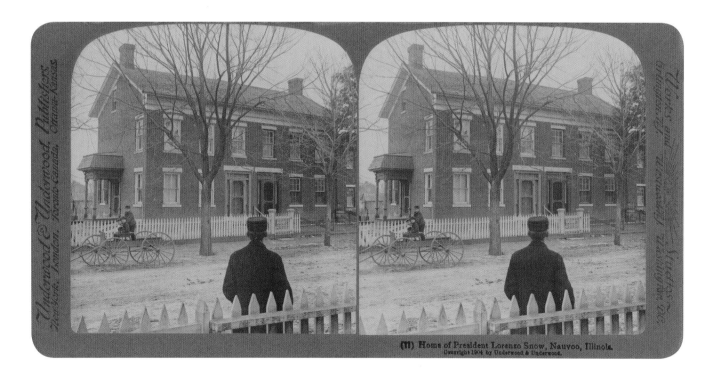

(11) Home of President Lorenzo Snow, Nauvoo, Illinois.
Copyright 1904 by Underwood & Underwood.

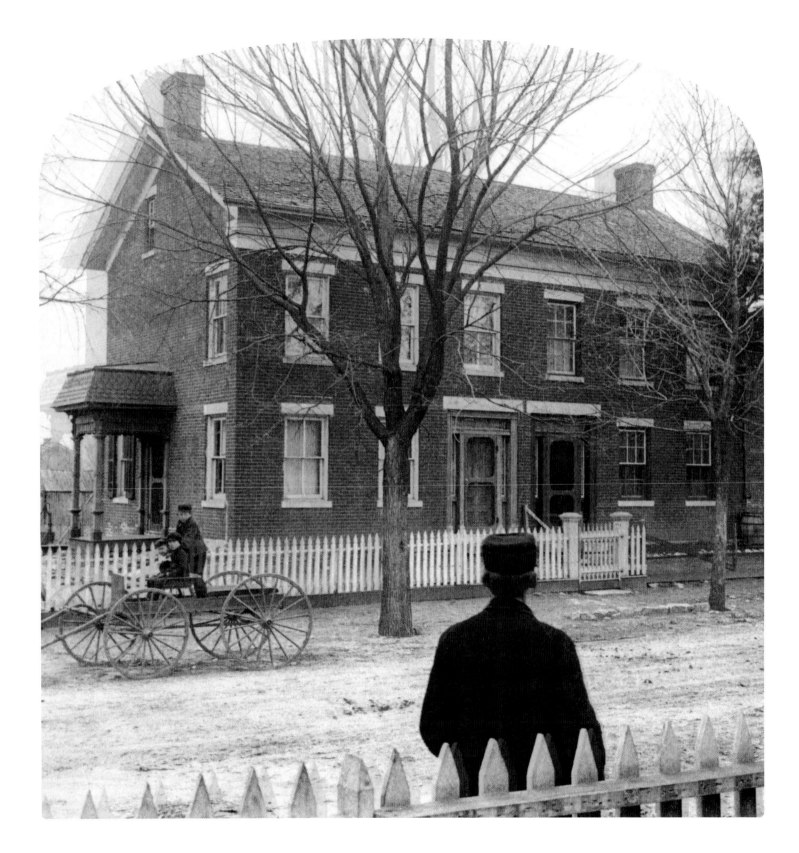

Nauvoo Mansion, Home of Joseph Smith, from which the murdered brothers were buried, Nauvoo, Illinois

The Nauvoo Mansion stands on the corner of Main and Water streets within one block of the river bank. The building is a frame "L" shaped structure, facing west and south. In the stereograph we are looking at it from the southwest. It received its name, "Nauvoo Mansion," not from its proportions or grandeur, but from the fact that it was a hotel as well as the residence of the Prophet Joseph Smith and his family. From the commencement of his public career the Prophet's home both at Kirtland and Nauvoo had been thronged with visitors. Sometimes the merely curious; sometimes sincere enquirers after truth; sometimes arrogant, inquisitive ministers came with the hope of refuting the Prophet's claims. All classes the Prophet received with open-handed hospitality, but it was a severe tax upon his resources, and therefore when in November, 1843, the "Mansion" was made ready for his occupancy, it was opened as a hotel, the Prophet being the proprietor. The management of it as a hotel, however, was in a few months turned over to Ebenezer Robinson, the Prophet reserving to himself and family three rooms only. The Nauvoo Mansion had the reputation of setting the best table and affording the best accommodations in what was called at the time the "Upper Mississippi Country." In those days there was no network of railroads as now throughout

Illinois, and traveling was either on horseback or by means of the stage coach. The care of horses, therefore, as well as of men, was a necessary feature of American hotel accommodations. It is said that the brick stables connected with the Nauvoo Mansion provided stalls for seventy-five horses, and that they were frequently all occupied.

It is as the residence of the Prophet Joseph Smith, however, that the Nauvoo Mansion derives its chiefest importance. It was here that he spent some of the happiest days of his troubled life. Here that he entertained his friends, and sometimes his enemies, with that open-hearted, and open-handed hospitality so characteristic of him. Here he feasted the poor, the halt, and the maimed of his own people, as well as some of the first men in the State of Illinois, lawyers, doctors, judges, politicians. Stephen A. Douglas, judge of the judicial district in which Nauvoo was located, was a frequent guest at his house. It was here that a few gleams of sunshine struggled through the black clouds that had over-hung the Prophet's life, and finally at the martyr-close of his heroic career, it was here that his mangled body lay in state beside that of his brother Hyrum, while the mourning people of Nauvoo silently passed by to look for the last time upon the forms of the Prophets they loved so well.

Not only did Joseph Smith and his family live in the Nauvoo Mansion the last year of his life, it is also where he and his brother Hyrum lay in state after their assassination.

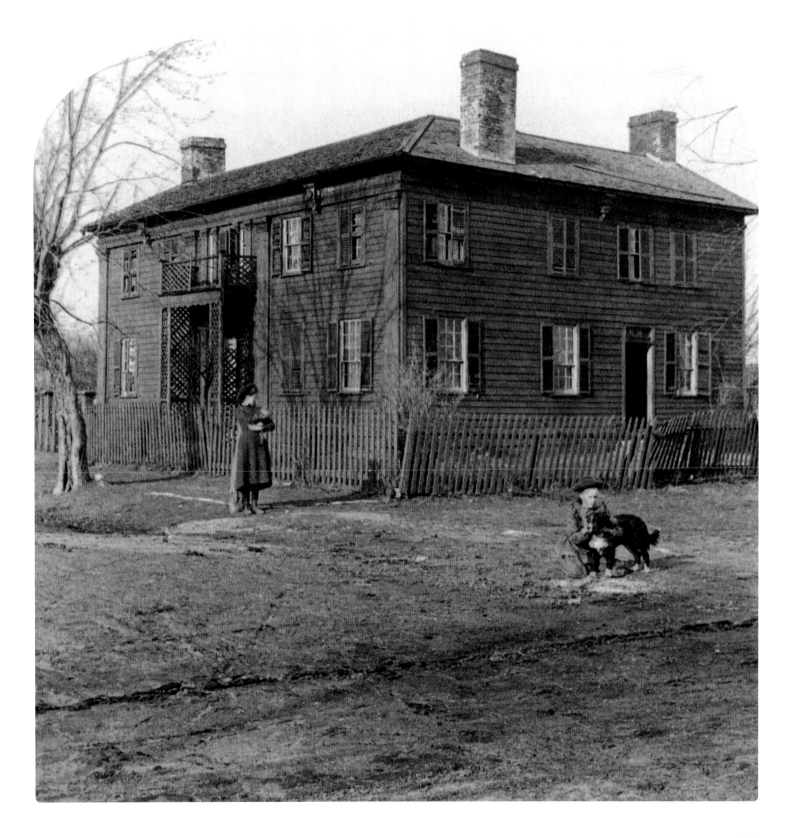

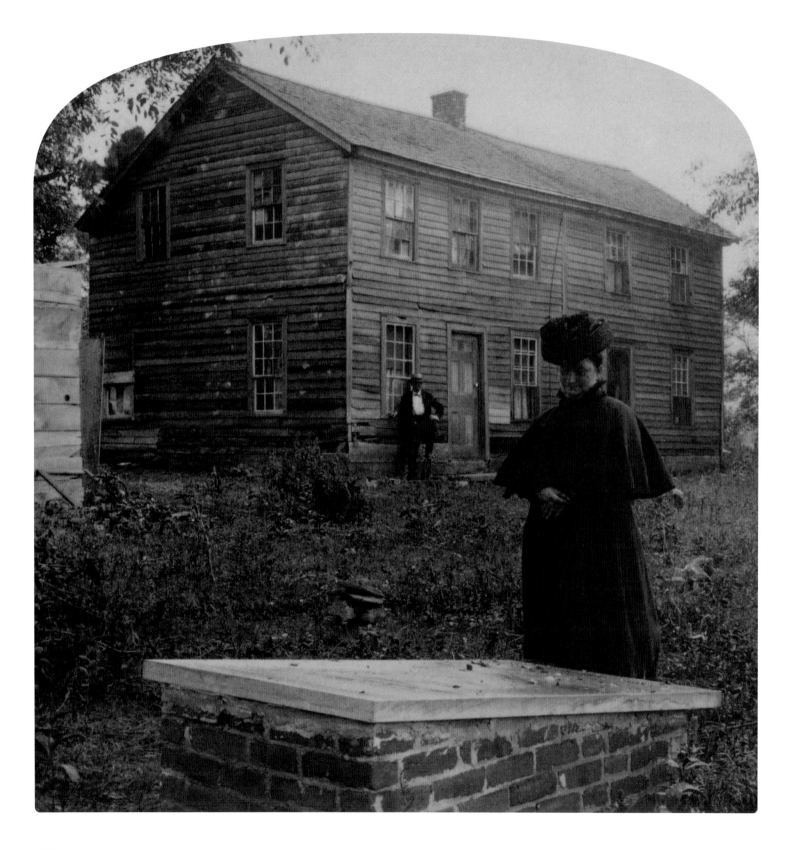

13 Old Smith Homestead, Emma Smith's Grave, and lot where martyred brothers were buried, Nauvoo, Ill.

Stereograph No. 13 is the old Smith homestead at Nauvoo, and is on the immediate bank of the Mississippi. In the stereograph we are looking northeast at the west end and front of the house. In the foreground is shown the grave of Emma Smith, which is supposed to be near the spot where the two prophets, Joseph and Hyrum, were buried. It appears that when "life's fitful dream was over" it was the desire of this toil-worn woman, Emma Smith, to be buried near the remains of the man by whose side she had stood for so many troubled years of life's existence. Peacefully may she slumber on the banks of the majestic river, which flows by her resting place a scant hundred yards distant.

Under the storage shed to the left (a "spring house," meaning it was constructed over a spring to keep stored food cool) is where the brothers' bodies were buried and remained hidden until 1928.

14 Home of President Brigham Young, Nauvoo, Illinois, facing north on Kimball Street

The home of the late President Brigham Young at Nauvoo faces north on Kimball Street. We are looking at it from the northwest. It is a plain, brick structure formerly enclosed by a low picket fence now removed. At the time of the death of the Prophet Joseph, Brigham Young was absent in the east on a mission. Returning to Nauvoo immediately upon hearing of the martyrdom, by virtue of his position as the President of the quorum of the Twelve Apostles, he found himself the chief man in Israel. His modest home therefore was frequently the scene of solemn councils whence instructions were sent forth for the guidance of the Saints, not only in the city of Nauvoo, but throughout the United States, Canada, and Great Britain. So that for a time this unpretentious Nauvoo building, the home of the second great "Mormon" leader, was in a manner the central office of the Church.

When the house was completed in May 1843, it consisted of the narrow central portion, and the two wings were added later.

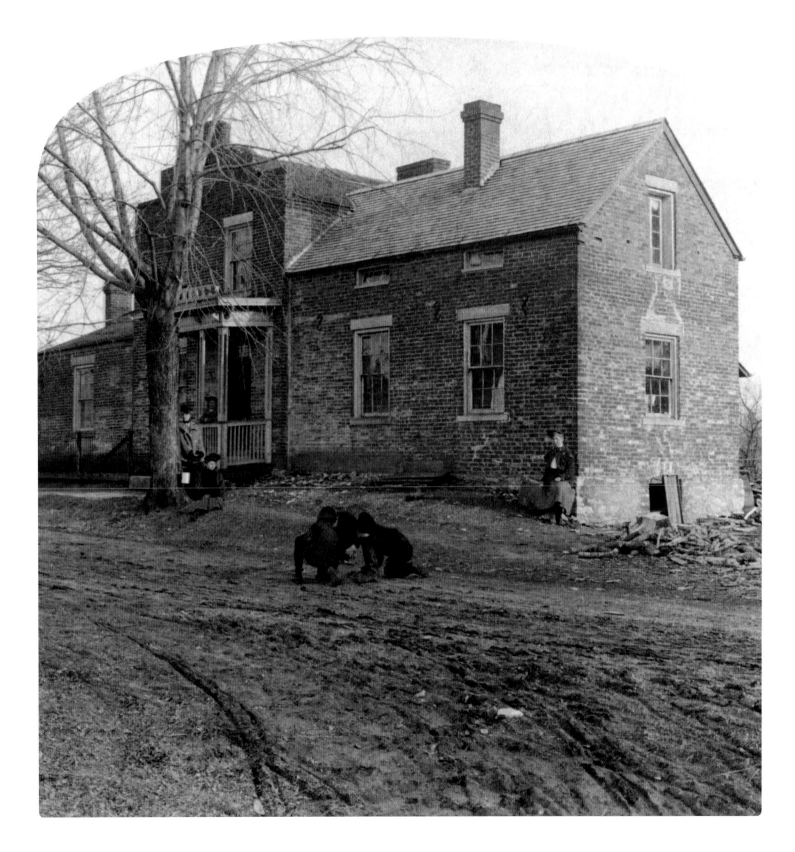

The late President John Taylor's two-story, brick house faced east on Main Street. We are looking at it from the southeast and see the front of the buildings and the south side. The building on the left was erected by Elder Taylor as a printing establishment, and here he printed the "Times and Seasons" of which he was editor and publisher. The building on the right was used as a store. The value of this group of buildings at the time Elder Taylor was exiled with the Saints from Nauvoo was estimated at $10,000. In addition to this property, a short distance east of Nauvoo he had a farm of one hundred and six acres of unimproved land; another of eighty acres, forty of which was under cultivation; the remaining forty was timber. He also had a corner lot one hundred and one by eighty-five feet on Main

and Water Street, opposite the Nauvoo Mansion. All this property, to say nothing of his printing and book binding establishment, and the furniture in his home, he was compelled to leave with but small hope of ever receiving anything for it, while he himself was driven forth an exile to wander in the wilderness, a victim of religious intolerance. His story is but one of many similar ones that could be related of his coreligionists who were driven from Nauvoo.

There were many homes besides these I have described that were left by the Saints to stand as monuments of the sacrifices they made for their religion, on the one hand; and as the monuments of the intolerance of religious bigotry on the other. It is gratifying that views of so many of these monuments have been preserved by Mr. Califf's stereographs.

John Taylor's home is known to have been located between the *Times and Seasons* printing building and the post office (below), and it is uncertain today whether the Sylvester Stoddard home and tin shop (shown to the right, with the post office to the left), had any connection to third LDS president John Taylor.

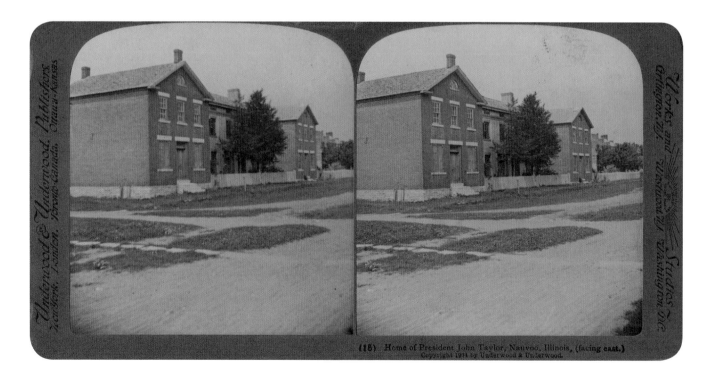

(15) Home of President John Taylor, Nauvoo, Illinois, (facing east.)
Copyright 1904 by Underwood & Underwood.

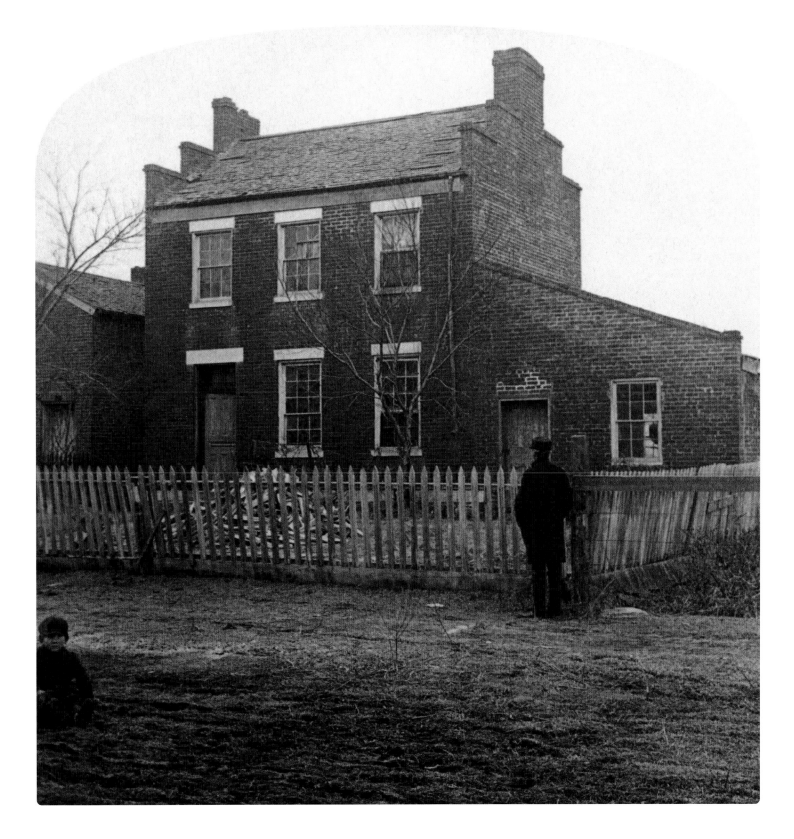

THE MARTYRDOM OF JOSEPH AND HYRUM SMITH

The six stereographs presenting views of Carthage prison and the Hancock county court house at Carthage, Illinois, will be better understood if the story of the Prophet's martyrdom precedes the description of them. It is well known that the declaration of the Prophet that he had received a new dispensation of the gospel of Jesus Christ, strangely agitated those to whom he first proclaimed it, and brought upon him the displeasure of the religious orders; that a relentless persecution followed him through all the years of his public career, constantly increasing and culminating finally in his martyrdom at Carthage, on the 27th of June, 1844.

By the time Nauvoo was well on the way to recognition as the coming metropolitan city of the west, a considerable number of those who had lost the faith lived in Nauvoo, and their bitterness was greater than that of other non-Mormon enemies of the Prophet. These apostates in the spring of 1844 started the publication of a paper called the "Nauvoo Expositor." As the policy which it proclaimed for itself threatened the peace and security of the city the municipal council declared it a nuisance, ordered its suppression, and it was suppressed. The press was broken and the type scattered. This afforded an opportunity for the Prophet's enemies to agitate the country against the people of Nauvoo in general and its mayor, the Prophet himself, in particular. A warrant for his arrest and the arrest of the members of the city council was issued by Mr. Morrison, justice of the peace at Carthage, and made returnable to the justice at Carthage, "or some other justice of the peace." Mr. Smith and the city council being assured that it was unsafe for them to go to Carthage, insisted upon being taken before some other justice of the peace as provided in the warrant. To this the constable refused his assent, whereupon the parties under arrest applied for a writ of habeas corpus made returnable before the municipal court of Nauvoo. The hearing was granted and the case dismissed. At the instance of Judge Thomas, the circuit judge of the judicial district which included Nauvoo, the parties submitted to a new trial on the same charge before Squire D. H. Wells, justice of the peace in one of the outlying precincts of Nauvoo, and they were again acquitted. The course pursued by the mayor and city council was declared [by opponents] to be resistance to the law[,] and made use of to influence the public mind against the Mormons. Mobs assembled about Carthage and the work of violence was inaugurated by kidnapping, whipping and otherwise abusing the Saints who lived in the outlying districts. For protection people thus assaulted fled to Nauvoo. This was heralded abroad as the massing of the Mormon forces. An appeal to the governor was made by both parties. Acting under his instructions the Nauvoo Legion was called out by the mayor of Nauvoo and the city placed under martial law for the protection of its people.

In the midst of the excitement Governor Ford arrived in Carthage, where he heard complaints from both parties to the controversy and expressed it as his opinion that it would be best for Joseph Smith and all concerned in the destruction of the Expositor press to come to Carthage and undergo trial on the charges against them, notwithstanding they had been twice examined and twice acquitted. In council with his friends upon the subject the Prophet came to the conclusion that it would be positively dangerous for himself and associates of the city council to go to Carthage, and finally concluded that the wisest thing to do would be for himself and a few other leading brethren against whom the mob was particularly enraged to leave for the west. In pursuance of this determination himself and others crossed the Mississippi to the Iowa side. Before they could depart for the west a delegation of false friends from Nauvoo arrived and besought the Prophet to return, intimating that he was playing the part of a false shepherd who in the hour of danger left his flock. Stung by this accusation the Prophet replied that if his life was nothing to his friends it was nothing to him; and against the promptings of his better judgment he returned to Nauvoo resolving to commit himself to the hands of his enemies in order to comply with the governor's advice. Arriving at Nauvoo he hastened to depart for Carthage, saying enroute that he

was going like a lamb to the slaughter; "but I am as calm as a summer's morning." He added, "I have a conscience void of offense toward God and toward all men. I shall die innocent and it shall yet be said of me he was murdered in cold blood." At Carthage the Prophet and the Nauvoo city council appeared before a justice of the peace and were bound over to the circuit court at its next session on peace and were bound over to the charge of riot. No sooner was this matter adjusted than Joseph and Hyrum Smith were arrested on a charge of treason against the State at the instance of Henry O. Norton and Augustine Spencer, men of no character and whose word was utterly unreliable. The arrested parties were thrust into prison, where they were completely at the mercy of their enemies. The friends of the Prophet protested to the governor against such treatment but to no purpose. Governor Ford was sorry that the thing had occurred. He did not believe the charge, but thought the best thing to do would be to let the law take its course.

On the 26th of June, there was a long interview between the Prophet and the governor in the prison. All the difficulties that had arisen in Nauvoo were related by Joseph and the action of himself and associates explained and defended. In concluding the conversation the Prophet said: "Governor Ford, I ask for nothing but what is legal; I have a right to expect protection at least from you; for independent of law, you have pledged your faith and that of the state for my protection, and I wish to go to Nauvoo." "And you shall have protection, General Smith," replied the governor. "I did not make this promise without consulting my officers, who all pledged their honor to its fulfillment. I do not know that I shall go tomorrow to Nauvoo, but if I do, I will take you along."

The next day—the ever memorable 27th of June—the governor broke the promise he had made to Joseph Smith the day previous, viz: that if he went to Nauvoo he would take him along. He disbanded the militia except a small company he detailed to accompany him to Nauvoo, and the Carthage Greys, a company composed of the very worst enemies of the Prophet and his friends— these he left to guard the prisoners! It was the public boast of the disbanded militia that they would only go a short distance from the town and then after the governor left for Nauvoo they would return and kill the Prophet. When this fact was stated to the governor by Dan Jones, one of the Elders of the Church,

who heard the boasts, Governor Ford replied that Jones was over anxious for the safety of his friends. The succeeding events of that day, however, proved that the boasts of the Prophet's enemies were not idle.

The afternoon of the 27th of June was a hot, sultry day. Two friends, John Taylor and Willard Richards, had been permitted to remain with the prisoners, Joseph and Hyrum Smith. The time was spent by the four brethren in desultory conversation and singing. Late in the afternoon Mr. Stigall, the jail keeper, came and suggested that it would be safer for them in the cells—the prisoners had been occupying the jailor's parlor. Joseph told him that they would go in after supper. A little after five o'clock a mob, with their faces painted black and variously disguised, suddenly appeared before the prison. They evidently had an understanding with the Carthage Greys, the militia company left in charge of the prison. The whole company was encamped about two or three hundred yards away on the public square about the court house, and they made no effort whatever to prevent the assault on the prison. The six men on guard duty at the jail played their part well. They fired blank shots at the advancing mob or discharged their pieces in the air, and were then "over-powered," and the prison was in the hands of the infuriated mob. Rushing through the front entrance they fired a volley up the stair-way and gained a landing before the door of the main prison and the jailor's parlor. Their associates on the outside at the same time were firing through the windows of the prison. At the first volley the four prisoners closed the door of their room against the entry at the head of the stairs and braced themselves against it, there being no lock on the door. By this time the mob had gained the landing and a shot was fired through the panel of the door which

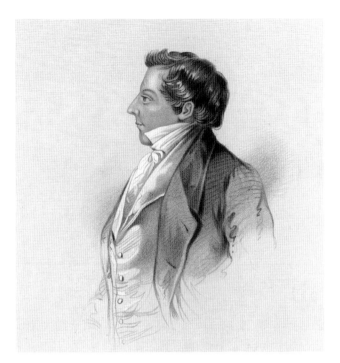

caused the friends to spring back to the front part of the room. Hyrum Smith staggered backward a few feet and fell, calmly saying "I am a dead man!" For a moment the Prophet bent over the prostrate form of his brother and said, "Oh! my poor, dear brother Hyrum!" Then instantly rising to his feet he stepped to the half-open door, through which the mob was firing and discharged at them a pistol left in his hands that morning by Cyrus Wheelock, one of the brethren who had visited him in prison. John Taylor and Willard Richards stood by him parrying the guns thrust through the doorway with their heavy walking canes. Three barrels of the old fashioned six-shooter in the hands of the Prophet missed fire. Meantime the crowd on the landing grew more dense and were forced toward the door by those crowding their way up the stairs.

There being no means of defense Elder Taylor sprang for the open window opposite the prison door. As he was in the act of leaping from the window a ball fired from the door-way struck him about midway of his left thigh and he fell helpless on the window-sill and would have dropped on the outside had not another ball from the outside at that instant struck the watch in his vest pocket, which threw him back into the room. He drew himself as rapidly as possible in his crippled condition under the bed that stood near the window. While doing so several other balls struck him in his leg and hip and arm. No sooner had Elder Taylor been thrown back from the window than the Prophet attempted to leap from it, and was shot and fell to the ground, exclaiming: "Oh Lord, my God!" Elder Richards had escaped without so much as a hole in his clothing. He saw the Prophet half leap, half fall from the window, and rushing to it saw his friend lying

dead, surrounded by the mob. He now started for the inner prison room and as he passed Elder Taylor the latter said, "Stop, doctor, and take me along." Ascertaining that the iron door to the criminal cell was open, the doctor returned and dragged his wounded companion across the landing into it. Once inside the cell he exclaimed, "Oh, Brother Taylor, is it possible that they have killed Brothers Joseph and Hyrum? It cannot surely be, and yet, I saw them shoot them. Brother Taylor this is a terrible event." He then dragged his wounded friend still further into the cell where he covered him with an old mattress, while he himself went outside to ascertain what further fate had befallen the Prophet. The mob, it seemed, as soon as the awful reality of their crime dawned upon them were seized with terror, and fled in various directions. Immediately under the window from which the young Prophet fell when shot was an old well curb, and here the sands of his life ebbed away, and another soul was added to the number under the altar "that were slain for the word of God and the testimony which they held." Inside the prison lay Elder Taylor in an agony of pain, weltering in his blood. In the jailor's parlor lay Hyrum Smith, stark in his martyrdom. "A monument of greatness even in death" as John Taylor observed of him. "Poor Hyrum," he continues,

 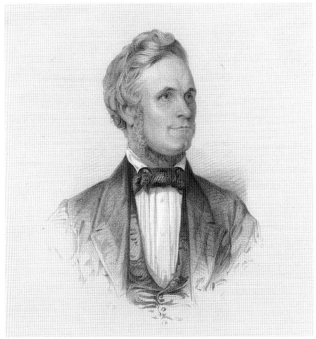

"he was a great and good man, and my soul was cemented to his. If ever there was an exemplary, honest and virtuous man, an embodiment of all that is noble in the human form Hyrum Smith was its representative."

Joseph Smith was innocent of any crime, as had often been proved before the courts of his country where he had been some fifty times arraigned, and as many times acquitted without condemnation. His death was the direct result of that bitter and relentless persecution which had followed him from the time the Lord first appeared to him and made him a Prophet to the nations; and in his death, so tragic, and so pitiful, he affixed a broad seal to the message he bore to the world—a seal that makes his testimony of binding force. "For where a statement is, there must of necessity be the death of the testator; for a statement is of force after men are dead: otherwise it is of no strength at all while the testator liveth." Not in vain fell the Prophet! Not in vain did his blood make crimson the soil of the great state of Illinois! It was fitting that the Prophet of the great Dispensation of the Fullness of Times should complete his work by sealing his testimony with his blood, that his martyr-cry: "Oh Lord, my God!" might mingle with the martyr-cries of so many of the prophets who, like him, were sent to bear witness for God.

But were not the murderers punished? No. At the October term of the Hancock circuit court a grand jury was impaneled. On Monday, the 21st of October, the court began its session. On Tuesday, the grand jury began their work, and by the following Saturday brought in two indictments, one for the murder of Joseph Smith and the other for the murder of Hyrum Smith. Nine persons in all were indicted. Most of these defendants appeared at once and demanded an immediate trial. This was objected to by the prosecution on the ground of not being ready, and the trial went over to the next term of court. On the 19th of May, 1845, the case again came before the court. Ninety-six men were brought into court before the trial jury of twelve could be obtained. The trial lasted till the 20th of May, when the jury was instructed by the court, and after several hours' deliberation returned a verdict of not guilty. "The case was closed," said Colonel John Hay (now—1904—Secretary of State in President Roosevelt's cabinet, who wrote up the trial in the Atlantic Monthly for December, 1869)—"the case was closed. There was not a man on the jury, in the court, in the county, that did not know the defendants had done the murder. But it was not proven, and the verdict of not guilty was right in law."

The engravings are Frederick Piercy's sketches of Joseph Smith, Hyrum Smith, Willard Richards, and John Taylor, from Route from Liverpool to Great Salt Lake Valley, ed. James Linforth, 1855.

16 The old Jail where the Prophet Joseph Smith and his brother Hyrum were murdered, south front, Carthage, Illinois

The old Jail where the Prophet Joseph Smith and his brother Hyrum were murdered, south front, Carthage, Illinois. This historic structure built in 1841 stands on the southwest corner of the block bounded by Walnut Street on the south and Fayette on the west and is one block north and two blocks west of the Hancock county court house. It is built of red sand stone. The walls are nearly three feet in thickness, and after the lapse of more than sixty years show no signs of decay. In stereograph No. 16 we are looking at the south end or front of the prison. The conservatory and porch formed no part of the original building, but the entrance is the same through which the mob forced its way to commit the awful crime of the 27th of June, 1844. The main door now, as at the time of the tragedy, opens into a hall. At the right, immediately in the south end of the hall, is a door that opens into the room that was used as the jailer's living room, and in the northeast corner of that room is a door opening into a small room used as the jailer's kitchen. The hall extends north from the main entrance to the door of the northwest room, which was called the "debtor's prison," and was the only room on the first floor used as a prison cell. Such in brief is the description of the lower floor of the old prison.

In addition to serving as the county jail, this building also was a home for the jailer and his family. In 1866 it was converted into a private residence. After the LDS Church bought it in 1903, it continued to be rented out until 1934. Now it is a museum that has been restored to its 1844 appearance.

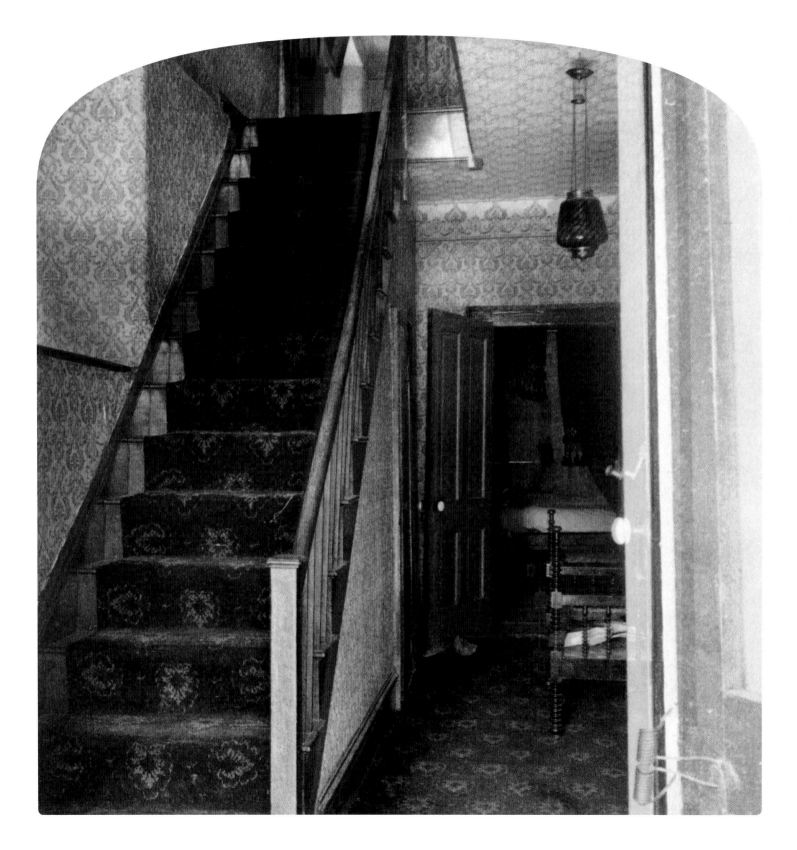

17 Hall, door in Debtor's Prison, stairway ascended by mob, and door to main Prison, Carthage, Illinois

Stereograph No. 17 shows the door at the north end of the hall leading to the debtor's prison, already spoken of, and the stair way on the left side of the hall leading to the landing on the second floor immediately in front of the main prison cell, and the jailer's parlor. It was up this stair-way that the mob first fired a volley and then rushed to reach the Prophet and his friends.

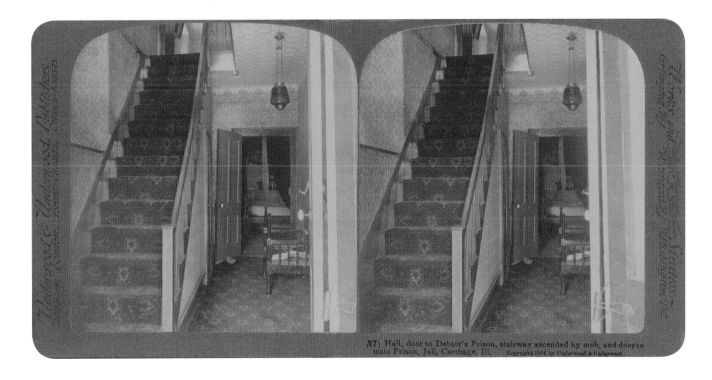

(17) Hall, door to Debtor's Prison, stairway ascended by mob, and door to main Prison, Jail, Carthage, Ill. Copyright 1904 by Underwood & Underwood

A 3-D TOUR OF LATTER-DAY SAINT HISTORY

18 Door to main Prison, Hall where mob stood while firing into Jailer's Parlor, Carthage, Illinois

This door-way leads to the main prison cell, which extended across the north end of the building, and immediately in front is the landing where the mob stood when firing through the door and into the room occupied by the prisoners at the time of the assault. It was across this landing and into this cell-room that Willard Richards dragged his savagely wounded friend, John Taylor, to a place, as he hoped, of security.

19 Jailer's Parlor where mob slew Joseph and Hyrum Smith; bullet hole in door— Old Jail, Carthage, Illinois

This is the room in which the Prophet and his friends were assailed, though now so cozy and peaceful in appearance. This was the door which the friends hastily closed when they heard the first shots fired by the mob. Through this door the shot was fired which is supposed to have struck Hyrum Smith in the face—the hole is seen in the panel of the door in this stereograph—and a few feet in the foreground from it is where he fell, calmly exclaiming, "I am a dead man." Near where the young man sits is where the Prophet stood as he fired upon the mob on the landing, and where Elders John Taylor and Willard Richards stood beside him, and parried with their walking canes, the guns thrust through the doorway.

The artist Frederick Piercy depicted himself (below) with a female guide in 1853. To the right is Jean Paul Califf, son of the project director, John Califf, in their home, the former jail, seated below a portrait of the Scottish poet Robert Burns.

20

East side of Jail, showing window where Joseph Smith was shot and from which he fell, Carthage, Illinois

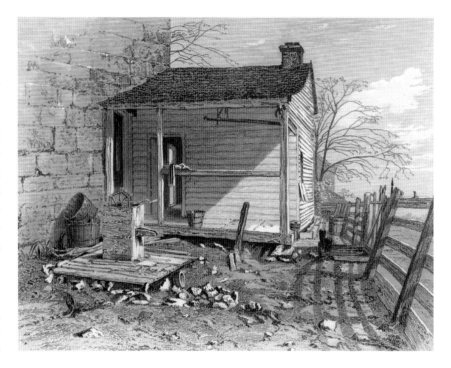

Here is seen the east side of Carthage jail. The upper window is the one from which John Taylor tried to leap, but was shot down in the act of doing so, and thrown back to the floor of the prison by a ball fired from the outside. It was at this window a moment later at which the Prophet Joseph appeared evidently with the intention of leaping to the ground and was shot while in the act. He fell directly under the window, near an old well-curb, and there the young Prophet breathed out his life.

Here we see John Califf himself (left) leaning out the window from which Joseph Smith fell. To the right is Piercy's sketch of the well "against which Joseph Smith was placed and shot at after his assassination."

21 Court House, scene of trial of the murderers of Joseph and Hyrum Smith, Carthage, Ill.

Hancock county court house shown in stereograph No. 21 is centrally located in the pleasant town of Carthage, Illinois. It stands in a well-kept public square which is four hundred feet on each side. The view presented is taken from the northwest. The court house is a substantial brick structure erected in 1839, though there have been some additions and changes made since the time of the tragedy. It was here that the trial of the murderers of the Prophet was held in 1844–5, the result of which has already been given in the general narrative of the martyrdom.

No longer to be seen, the courthouse was razed in 1907. The first case tried there in 1839 featured attorney Abraham Lincoln, who represented a man accused of murder. Lincoln lost the case.

Brigham Young was born at Whitingham, Windham county, in the State of Vermont, June 1, 1801. He was therefore at the death of the Prophet Joseph Smith forty-three years of age—in the very prime of his manhood. By virtue of his position as president of the quorum of the Twelve Apostles he was recognized as the chief man in the modern Israel; and he at once inaugurated a vigorous administration of the affairs of the Church. The Saints soon recognized in him the master spirit of their now martyred Prophet, and supported him and his associates most loyally. The work which had for a moment halted because of the death of the Prophet, again moved forward in all its departments. Increased activity was awakened in the missions throughout the United States, Canada and Great Britain. The gathering of the people to Nauvoo was encouraged. The work upon the temple and other public buildings was resumed and those who expected to see Mormonism die with the martyrdom of its first Prophet–leader discovered they were doomed to disappointment, and straightway renewed their opposition. Less than ten days before his death the Prophet Joseph used this language:

> It is thought by some that our enemies would be satisfied with my destruction; but I tell you that as soon as they have shed my blood, they will thirst for the blood of every man in whose heart dwells a single spark of the spirit of the fullness of the Gospel. The opposition of these men is moved by the spirit of the adversary of all righteousness. It is not only to destroy me, but every man and woman who dares believe the doctrines that God has inspired me to teach in this generation.

This prophecy was soon in the way of fulfillment. Slanders were rife through all parts of the country defaming the city of Nauvoo and her people. The Saints living in outlying districts were assailed by mob violence, and from time to time Nauvoo was threatened with destruction. The necessary steps to self-protection from these assaults were construed into acts of aggression and menace to the peace of the state, until such distrustful and unfriendly public sentiment was created that it became evident that if the Saints were to have peace, and enjoy any part of that religious freedom guaranteed in both state and national constitutions they must seek it elsewhere than in the state of Illinois, or even in the United States. This was soon discerned by the new and farseeing leader, Brigham Young; and, indeed, had long been foreseen by Joseph Smith who had predicted the removal of his people to the Rock[y] Mountains, where in his vision he had seen them become a numerous and powerful people. He himself had set on foot some preliminary measures looking forward to the exodus of the Church to their predicted location in the west. So that the movements of Brigham Young in this respect had for their object carrying out the plans of his predecessor. But bitter opposition and mob violence on the part of the people of Illinois, who refused to consider the settlement of the Mormon difficulties on any other basis than that of the removal of the Mormons from the state, hastened the consummation of these plans. Under date of September 24, 1845, in a communication to a committee of citizens appointed at Quincy President Young in behalf of the council of the Twelve announced to the people of Illinois and the surrounding states and territories the intention of himself and his people to leave Illinois in the following spring for some point so remote that there would be no difficulty between the Latter-day Saints and the citizens of Illinois; and asked for assistance in the accomplishment of this purpose by a fair exchange of such property as his people could take with them into the wilderness, for the homes and lands they must leave.

Then followed busy days in Nauvoo. In order to be ready for the great exodus in the spring men were hurrying to and from collecting wagons and repairing them. The roar of the smith's forge was well-nigh perpetual and even the stillness of night was broken by the steady beat of the sledge and the merry ringing of the anvil. Committees were seeking purchasers of real estate and converting both that and personal property into anything that would be of service to those just about to plunge into an unknown and boundless wilderness.

While these efforts were being put forth on the part of the people of Nauvoo to fulfill their agreement to the mob forces incidents of mob violence against them were almost of everyday occurrence. In order, therefore, to give evidence of the earnest intentions of the Mormons to leave the state, and that these persecutions might cease the Twelve Apostles and other leading brethren with their families crossed the Mississippi on the ice on the 11th of February, 1846, and were soon lost to view in the wilderness of Iowa. Other companies continued to follow as fast as they could make ready, so that by the latter part of April the great body of the Church had left Nauvoo. The advance companies made their way to a point on the Missouri river which they called Council Bluffs—the modern city of that name occupies the site of their encampment. To tell in detail the story of that journey from Nauvoo to Council Bluffs —how the Saints struggled on through trackless prairies converted into vast bogs by the spring thaws and rain and sleet which seemed to fall continuously; how the bleak winds from the pitiless northwest were more cruel than the sharpest frosts; how the young and strong left the main companies to go into Missouri and districts in Iowa remote from their line of march to exchange household furniture for corn or flour; how those who had merely enough provisions for themselves—no one had a surplus—divided with those who had none; how heroically they struggled against weakness and disease brought on through exposure; how they laid away their dead in nameless graves—to tell all this would fill a volume of itself, and belongs rather to a general history than to these sketches.

The Mormon encampment at Council Bluffs is thus described by General Thomas L. Kane, who visited it in June following the exodus from Nauvoo:

> They were collected a little distance above the Potawatomie Agency. The hills of the high prairie crowding in upon the river at this point and overhanging it, appear of an unusual and command elevation. They were called the "Council Bluffs." ... To the south of them, a rich alluvial flat of considerable width follows down the Missouri some eight miles, to where it is lost from view by a turn, which forms the site of an Indian [agency] town *Point aux Poules*. Across the river from this spot the hills recur again, but are skirted at their base by as much low ground as suffices for a landing. This landing, and the large flat or bottom on the east side of the river, were covered with carts and wagons; and each one of the Council Bluff hills opposite was crowded with its own great camp, gay with bright white canvas, and alive with the busy stir of swarming occupants. In the clear blue morning air the smoke streamed up from more than a thousand cooking fires. Countless roads and by-paths checkered all manner of geometric figures on the hillsides. Herd boys were dozing upon the slopes; sheep and horses, cows and oxen were feeding round them, and other herds were in the luxuriant meadows of the then swollen river. From a single point I counted four thousand head of cattle in view at one time. As I approached, it seemed to me the children there were to prove still more numerous.

The site of this encampment and vicinity was destined to be the point for some years to come from which companies would make their preparations for the journey through the western wilderness. Here President Young received his revelation directing the manner in which the companies should be organized and travel. The plan of organization for traveling was to divide the people into companies of one hundred wagons, sub-divided into companies of fifty wagons, and ten wagons, with captains over each division, the captains of fifties being subordinate to captains of hundreds, and captains of tens being subordinate to captains of fifties—all being subject to the direction of the Apostles. Each fifty had a blacksmith with tools for repairing wagons and shoeing animals. Three hundred pounds of bread stuff were required for each person. Every man had to have a gun with one hundred rounds of ammunition; and each family was expected to take along its proportion of seed grain and agricultural implements. As fast as individuals and families were found who had the required outfit, or could obtain it, they rendezvoused at a point on the Elk Horn river, a few miles west of Winter Quarters, where the organization for the journey to the mountains was perfected.

The pioneer company left Winter Quarters for the west in the month of April, 1847. It consisted of one hundred and forty-three men, three women and two children. They had seventy-three wagons, drawn by horses and mules, and loaded chiefly with grain and farming implements, and with the necessary provisions for the journey.

On the morning of July 24,1847, a canvas-covered, two-horse carriage might have been seen emerging from one of the canyons on the east side of the Salt Lake valley. On one side the canvas cover was rolled up, and lying upon an improvised couch a sick man was reclining. As soon as the carriage emerged from the canyon the driver left the rough, new made road and turned the open side of the carriage to the west and halted. The sick man arose to his feet for a few moments and gazed out over the valley. For a while he seemed wrapped in vision, then, turning to the driver, he said: "This is the place, drive on;" and sank back upon his couch. The speaker was Brigham Young. The driver was Wilford Woodruff.

The most of the pioneer company had preceded the great leader into Salt Lake valley by a day or two. About noon President Young reached their encampment, on one

of the streams flowing into the valley from the east side, and now known as City Creek. The encampment was formed not far from the Temple Square of Salt Lake City. The stream had been turned from its banks so as to overflow several acres of the parched land, and this was being plowed. Wilford Woodruff, who had brought with him a bushel of potatoes, took them from his wagon and planted them in the newly plowed ground. In thirty-three days the pioneers had laid out Salt Lake City much as it is to-day; built a fort, covering ten acres, enclosing the east side with log houses and the other three sides with adobe walls. Thus the settlement of Utah was begun.

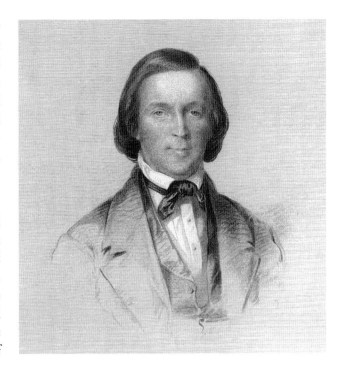

Pen Picture of Brigham Young

President Young, who conducted this marvelous exodus from Nauvoo, and lead the pioneers to the Salt Lake valley, stood about five feet and ten inches in height. He was of full form, compactly built, and of stately bearing. The head was massive, the hair abundant and of a light auburn, and of soft, fine texture. The forehead was high and broad at the base; the nose slightly inclined to be aquiline; the eyes were full and of a light gray, the mouth was well formed, and the whole face expressive of great firmness. Ordinarily he was mild and gentle and affectionate in his manner. Easily approached, and lovable; but capable of anger that was terrible. In him indeed was blended the strong and gentle qualities that go to the making of the highest and truest manhood. It goes without saying that he was a natural leader of men. That is universally conceded, for no person came into his presence but felt both the attractiveness and forcefulness of his nature. In the minds of his people he was possessed of a power beyond that which arose from the natural strength of his character. He was susceptible to inspirations which they referred to a divine source, and he was clothed with the priesthood. That is, he held delegated power from God, which made him, to them, a prophet—vice-regent of God on earth—and his inspired utterances, therefore, were the word of the Lord to them. All this he derived from the virtue of the position he held rather than from his natural attributes of leadership, though I would not detract from the natural abilities of leadership he possessed. Indeed, I believe God in choosing leaders selects those who by their natural endowments are capable of exercising the divine authority be bestows upon them. So that when God chooses a leader for His people, the natural endowments enlightened by a divine inspiration, gives to the people a leader indeed. Such an one was Brigham Young.

The portrait of Brigham Young (p. 81) was taken by Utah photographer Charles R. Savage in 1876, with added flowers to give the picture a 3-D effect. Above right is Piercy's idea of how Young may have looked when he guided the first wagon train to the Salt Lake Valley. In Roberts's narrative, a "pen picture" is a written description of a person.

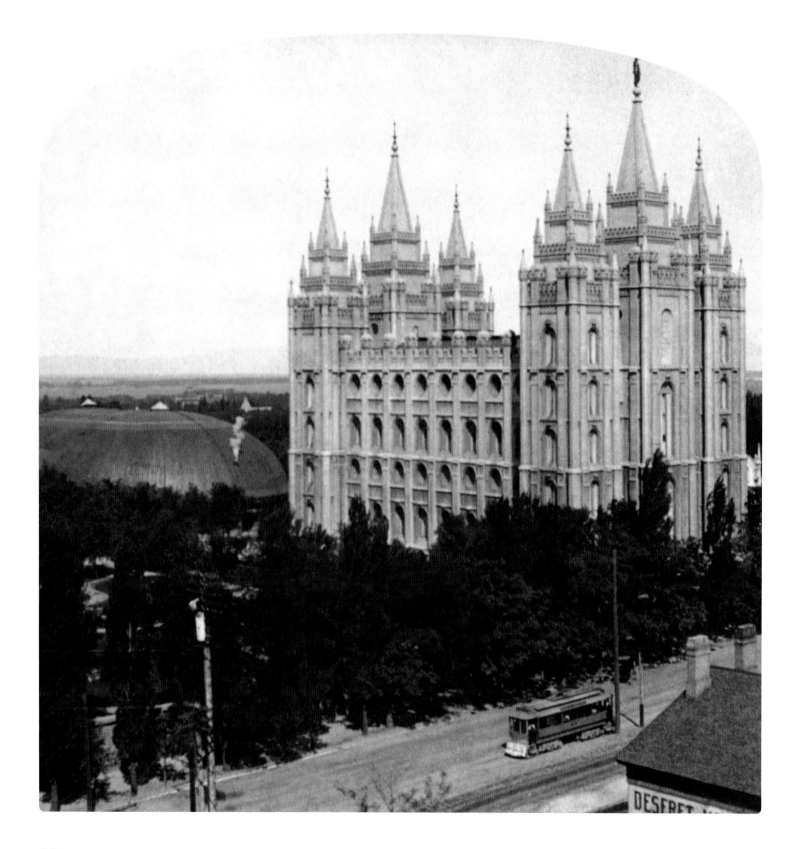

23 The Great Temple and the Tabernacle, cost of Temple, $4,000,000, height 210 feet, Salt Lake City, Utah

This view of the Mormon Temple and Tabernacle is from the sixth story of the Templeton building, and shows the east front and south side of the great granite structure. The length of the building is 186½ feet by 99 feet. There are six towers, three on the east and three on the west respectively. The height of the central tower on the east is 210 feet. The figure of the angel surmounting its top is 12½ feet in height. It is made of hammered copper and gilded with pure gold leaf. Surmounting it is an incandescent electric light of 100 candle power. The idea conveyed by the statue is that of a herald or messenger in the act of blowing the trumpet sounding the gospel message to all the world. The height of the other towers in the east end is 188 feet respectively, each surmounted by electric lights. The height of the central tower in the west is 204 feet, and of the other towers in the west end 182 feet respectively. All are surmounted by electric lights. The height of the Temple walls to the square is 167½ feet. The thickness of the walls in the first story are nine feet. Those of the upper story six feet. The thickness of the buttresses are seven feet, and the whole rests upon a foundation wall 16 feet thick, and 16 feet deep. The building covers an area of 21,850 feet.

It would be difficult to classify the style of architecture of this structure. It is unique as a piece of of religious architecture, but beautiful, chaste and impressive. It is strictly original and was designed chiefly by President Brigham Young. The history of its construction in outline is as follows: On the 28th of July, 1847, four days after his arrival in the Salt Lake valley, and after short exploring excursions had been made in various directions, President Young, accompanied by a number of the Twelve, while walking above the encampment formed on City Creek, suddenly stopped, looked about him and striking his walking cane into the ground, said: "Here will be the temple of our God." Wilford Woodruff secured a stake and drove it into the spot indicated by President Young. When Salt Lake City was surveyed it was found that this spot so marked was near the center of what is now called Temple Block. At the conference held in April, 1851, the congregation unanimously voted that a temple should be built. The inhabitants of Salt Lake at that time numbered but about 5,000, and there were about as many more in the surrounding settlements. It was not until two years

later, however—14th of February, 1853—that actual work, in pursuance of this action was begun. Ground was then measured and laid off under the direction of the First Presidency and Apostles, and the ground was broken for the foundation. On the 6th of April following[,] the respective corner stones were laid with impressive ceremonies.

At first it was decided that the structure should be made of adobes—sundried brick—with a red sand-stone foundation; and a wooden railway was constructed to the Red Butte stone quarries directly east of Salt Lake City to secure the material for the foundation. In the meantime granite quarries at the mouth of Little Cottonwood canyon, twenty miles distant, were opened and this splendid material was at once decided upon for the whole building. For a long time the stone was hauled from the quarries by ox teams, and it frequently took four days to bring a single stone from the quarries to the Temple Block. After the advent of railroads into Utah, 1869–70, a line was constructed to the stone quarries and thereafter the great granite blocks were brought into the square by train loads. On the 6th of April, 1892, the cap stone of the Temple was laid amid imposing ceremonies, and great rejoicing of the people, who assembled in the Temple block to the number of 40,000, while many more thousands thronged the adjoining streets. Finally, after 40 years of continuous work, the great structure, at a cost of $4,000,000, was completed in every detail, and ready for dedication unto the Lord for the specific purposes for which Temples are used by the Latter-day Saints. The dedicatory services began on the 6th of April, 1893, and were repeated daily until April 24th. Thirty-one meetings in all were held at which 75,000 people attended.

A short time previous to its dedication the respectable non-Mormons of Salt Lake and surrounding cities were invited to go through the Temple, an opportunity of which thousands availed themselves, and loudly applauded the courteous action of the Church authorities.

Notice the streetcar and the new *Deseret News* offices completed in 1904 on the site of the tithing yard, where people used to bring commodities to donate to the church.

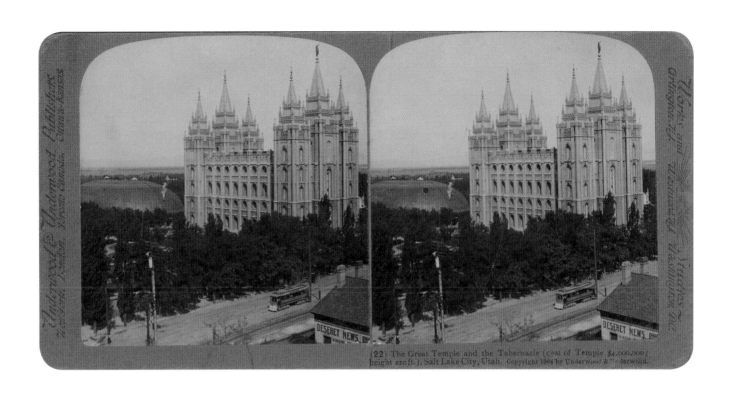

(22) The Great Temple and the Tabernacle (cost of Temple $4,000,000; height 210 ft.), Salt Lake City, Utah. Copyright 1904 by Underwood & Underwood.

This monument stands at the junction of Main Street and South Temple facing south, and from our point of view a little east of south the Temple rises as a background. It was erected in honor of President Brigham Young and the pioneers of Utah. The base and pedestal are of light grayish granite—the same as used in the Temple—the graceful granite shaft on which the heroic bronze statue of Brigham Young stands weighs twenty tons, and the whole monument from base to top stands thirty-five feet high, the figure of Brigham Young being 11½ feet. On the east side at the foot of the main shaft in a sitting posture is a native Indian. On the west side in a sitting posture is the old time trapper and frontiersman. Both figures are in bronze and very life-like. On the south side of the main shaft in relief is a full length bronze figure of a typical pioneer in the midst of his encampment. Immediately under this figure is a bronze tablet three feet long by one and one-half feet wide [tall] containing the inscription, "In honor of Brigham Young and the pioneers." On the north side is a plate of the same size and material on which the names of the first company of pioneers is inscribed. The sculptor has caught the pose of Brigham Young at the moment of his prophetic–historic utterance—"Here will stand the Temple of our God:" to which some add also, as part of his utterance, "And here we will build our city." The whole group was designed and executed by the Utah-born sculptor, C. E. Dallin. The angel on the east center tower of the Temple is also Mr. Dallin's work. He is a student from the Julian Academy, Paris, Henri Michael Chapu being his instructor. He has won fame in the art centers both of the old and the new world. His most celebrated works, perhaps, are "The Signal of Peace," Lincoln Park, Chicago; and the "Medicine Man" Fremont Park, Philadelphia. Both subjects are closely allied in spirit to his work in the Pioneer Monument.

The monument is a most fitting tribute to the pioneers of Utah, and will for generations to come commemorate the hardships they endured and the sacrifices they made in order to establish an outpost of that civilization which in those years was moving across the great continent of North America. "It is written that Peace hath her victories no less renowned than those of War," and it is fitting that the triumphs of peace should be celebrated in the monuments which men erect to commemorate great achievements. This monument is a memorial to a race of men whom succeeding generations honor themselves in honoring.

> Simple their lives yet their's the race
> When liberty sent forth her cry,
> Who crowded Concord's heights of red—
> Through years by hope were lead,
> And witnessed Yorktown's sun
> Set on a nation's banner spread—
> A nation's freedom won.

The poem is roughly paraphrased from Alfred B. Street's "The Settler." The New York State Librarian, Street was an acclaimed mid-nineteenth-century poet. To the right, the baseball game advertised on the front of the streetcar was between the Salt Lake Elders and Spokane Indians, two teams in the Pacific National League.

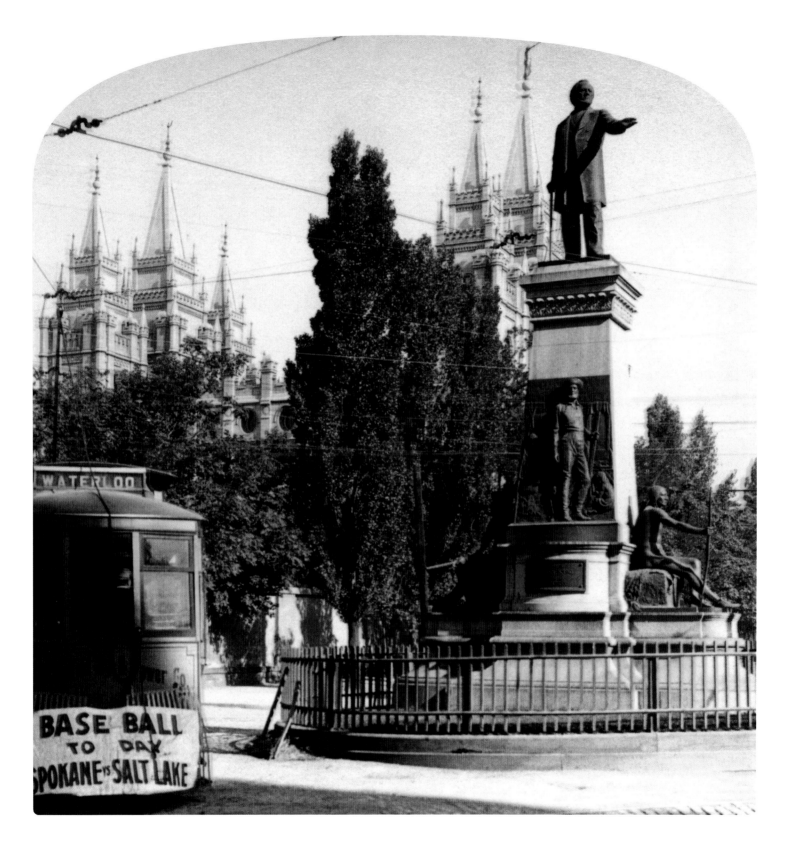

A 3-D TOUR OF LATTER-DAY SAINT HISTORY

25 The East Side of Temple Block, looking north, Salt Lake City, Utah

This is a fine view of the east side of the Temple Block and gives some idea of the length of Salt Lake squares or block. The city in the main is laid off with streets running at right angles eight rods [132 feet] wide, with sidewalks twenty feet wide. Each of the blocks includes ten acres. The blocks are therefore forty rods [660 feet] long. The present view shows the east side of Temple Block. The wall on the left entirely encloses the Temple square. It is ten feet high. The foundation and coping are of red sand-stone. The main body of the wall and pilasters, of which there are thirty on each side, are of adobes plastered with hard cement. This wall, completed seven years after the arrival of the pioneers, is a unique feature of Salt Lake City.

The Tabernacle, of which No. 26 is an interior view, was commenced in 1865, and two years later was so far completed that the general conference of the Church was held in it, but it was not fully completed until 1870. The building is 250 by 150 feet and stands 80 feet high. Its seating capacity is 8,000. The organ, which is seen in this view from the gallery, is in the west end of the building. Immediately on the right and left of the organ are the Choir seats for 500 members; and immediately in front the three tiers of pulpit-stands for the authorities of the Church. The following is a description of the organ:

> The front towers have an altitude of 58 feet, and the floor dimensions of the organ are 30 by 33 feet; it has 110 stops and accessories, and contains a total of over 5,000 pipes, ranging in length from one-fourth inch to 32 feet. It comprises five complete organs—Solo, Swell, Great, Choir and Pedal; in other words, four key boards in addition to the pedals. It is capable of 400 tonal varieties. The different varieties of tone embodied in this noble instrument represent the instruments of an orchestra, military band, choir, as well as the deep and sonorous stops for which the organ is famed. There is no color, shade or tint of tone that cannot be produced upon it. The action is the Kimball Duplex Pneumatic. The organ is blown by a 10-horse power electric motor, and two gangs of feeders furnish 5,000 cubic feet of air a minute when it is being played full. The organist is seated twenty feet from the instrument, which places him well amongst the choir. Undoubtedly the organ owes much to the marvelous acoustics of the Tabernacle, but even with this allowance made, it is still the most perfect instrument of its kind in existence. Free public recitals are given semi-weekly (during the summer months) by Professor J. J. McClellan, the Tabernacle organist, aided by the best vocal talent.

This splendid instrument was constructed over 30 years ago by Utah artisans, and chiefly from native materials. It was built under the direction of Joseph Ridges, and recently underwent extensive repairs, and was revoiced according to the modern schools of organ building, the work being done by the firm of W. W. Kimball & Co., of Chicago. The organ recitals through the summer months are one of the attractions of Salt Lake City to the tourists who visit Utah, as well as to her resident population.

The Mormon Church authorities have been very liberal in according to noted ministers of other persuasions the privilege to hold forth from the Tabernacle pulpit. The building has also been used for special services by Protestant and Catholic societies of both educational and religious character.

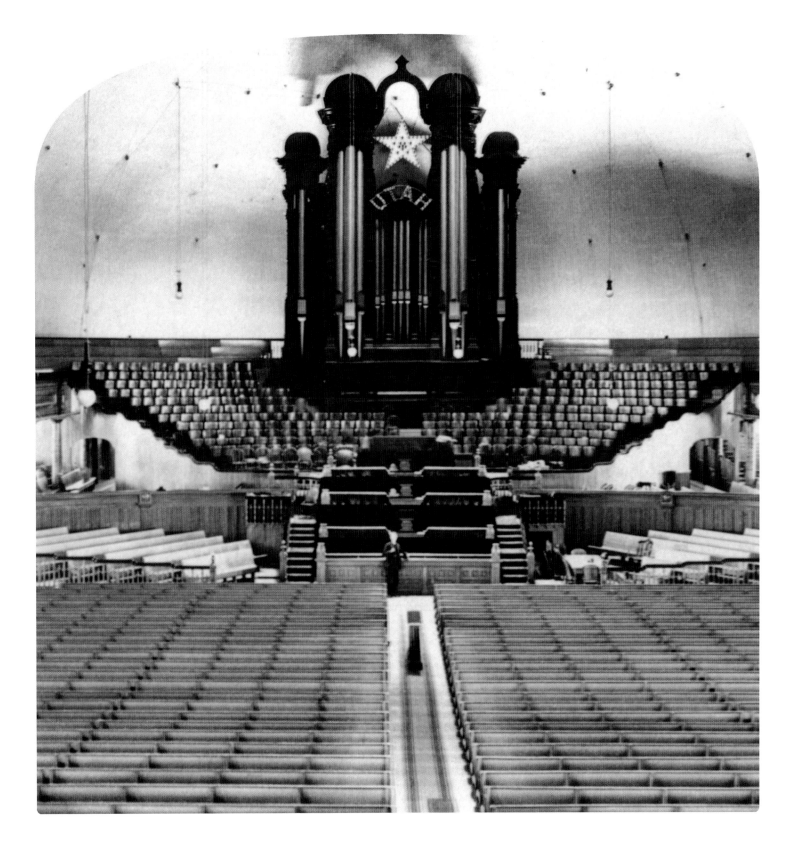

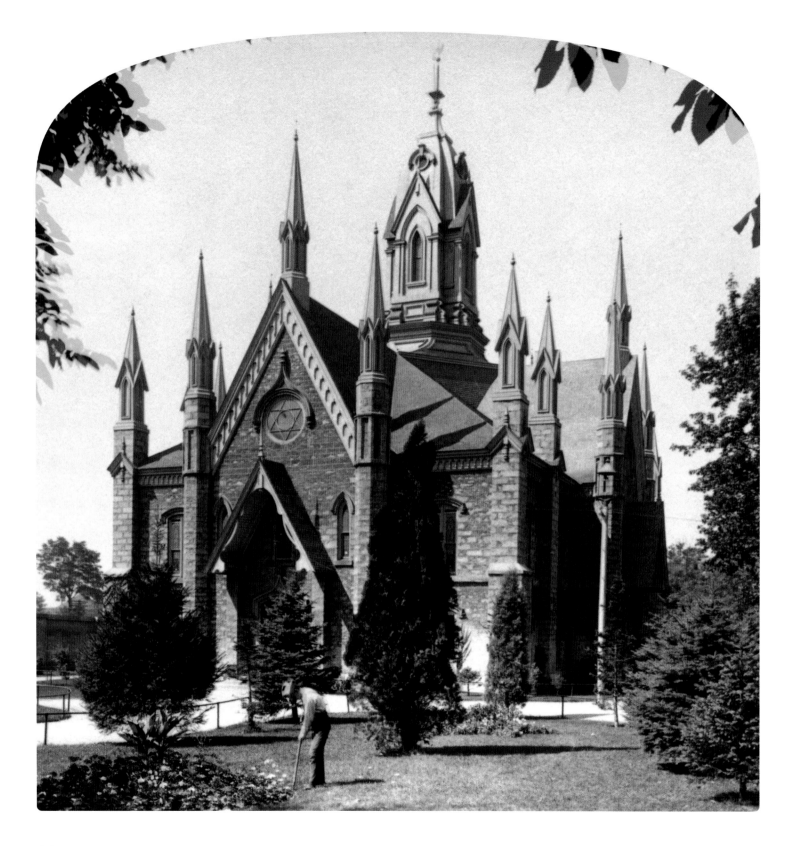

27 Assembly Hall, Temple Block—Gothic Architecture, seating capacity 3,000, Salt Lake City, Utah

The Assembly Hall was erected to accommodate smaller congregations than could with advantage convene in the Tabernacle. The building is 68 by 120 feet and the height of the central tower is 130 feet. In the interior is a gallery extending around three sides of the building. In the west end is a fine pipe organ, and immediately in front of it three tiers of stands—as in the Tabernacle—for the accommodation of speakers and Church authorities. The corner stone of this building was laid in September, 1877. It was completed and dedicated five years later—January 8, 1883. The building is of mixed hewn and rough granite. Its seating capacity is estimated at 3,000.

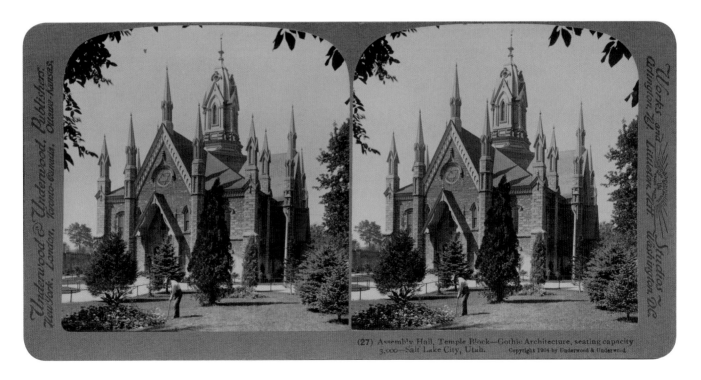

(27) Assembly Hall, Temple Block—Gothic Architecture, seating capacity 3,000—Salt Lake City, Utah. Copyright 1904 by Underwood & Underwood.

28 The Beehive House, Official residence of President Joseph F. Smith, Salt Lake City, Utah

The Bee Hive House, at present the official residence of Joseph F. Smith, the President of the Mormon Church, stands on the corner of State and South Temple street, immediately west of the Eagle Gate, one of the pillars of which is seen on the right. It was formerly one of the residences of the late President Brigham Young. It is called the Bee Hive House, because the box observatory rising from the roof was surmounted by a bee hive, the emblem of the State, signifying industry. The bee hive, it will be remembered, since statehood, has become the official seal of the State of Utah. The house is of the old Colonial style of the New England States, and its interior arrangement is commodious and homelike. Immediately below the Bee Hive House is seen the small buildings which constitute the offices of the First Presidency of the Church. In this stereograph we are looking from the Southeast.

Joseph F. Smith was living here in 1904. When he died in 1918, the Beehive House was converted into a boarding house and remained so until 1960 when it was restored to its original design and opened as a museum.

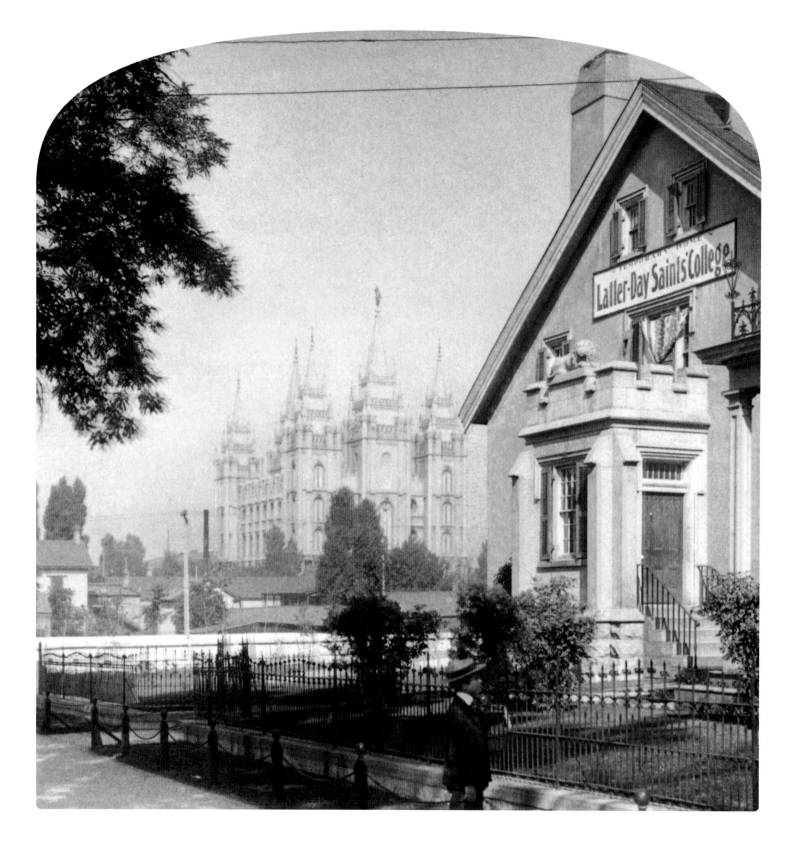

A 3-D TOUR OF LATTER-DAY SAINT HISTORY

29 The Lion House and the Great Temple at distance, northwest, Salt Lake City, Utah

In this view we see the south end of the Lion House, also one of the residences of the late President Brigham Young. It takes its name from the sculptured stone lion seen in repose above the portico which forms the entrance to the building. It is an adobe structure plastered with hard cement, resting on a foundation of red sandstone. The Lion House stands immediately below the Church offices on South Temple street and faces south. We are looking to the northwest and get an excellent view of the many spired Mormon Temple in the distance. For a number of years the Lion House has been used as the temporary home of some departments of the Latter-Day Saints University.

For a brief time, the Lion House was utilized by the Latter-day Saints College, which came to occupy much of the block (Samuel M. Barratt Memorial Hall, Brigham Young Memorial Hall, old Business College Classroom Building, old Deseret Gymnasium, Manual Training Building, Science Department Classroom Building), with other buildings in the vicinity where the school rented space (Ellerbeck Building, McCune Mansion, Seventeenth Ward chapel, Templeton Building, Wall Mansion, and Whitney House). See Lynn M. Hilton, The History of LDS Business College and Its Parent Institutions, 1886–1993 (Salt Lake City: LDS Business College, 1995), 93–116, online at Internet Archive, https://archive.org.

This palatial residence in the Elizabethan style of architecture was built by President Brigham Young for an official residence. It was originally called the Gardo House, but being designed, as is generally supposed, as the home of his wife Amelia Folsom, it in time came to be called Amelia Palace. The building stands on the corner of State street and South Temple. We are looking at it from the northeast and see the north and east front. In the latter part of December, 1881, the Amelia Palace, then called the Gardo House, became the official residence of President John Taylor, who succeeded Brigham Young in the Presidency of the Mormon Church. For some years after the demise of President Taylor, it was retained as the residence of leading Church officials. This building, regarded as one of the handsomest residences in Salt Lake City, or the inter-mountain west, is at present the property of Mrs. Susanna B. Emery Holmes, a non-Mormon but a very public-spirited and charitable lady. She retains for her magnificent home the name Amelia Palace; and it is one of the chief centers of social life in Salt Lake.

The Gardo House was torn down in 1921, replaced by a bank and later by a modern office building.

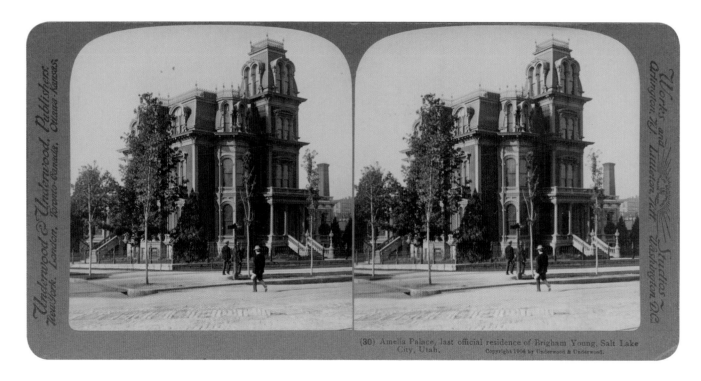

(30) Amelia Palace, last official residence of Brigham Young, Salt Lake City, Utah. Copyright 1904 by Underwood & Underwood.

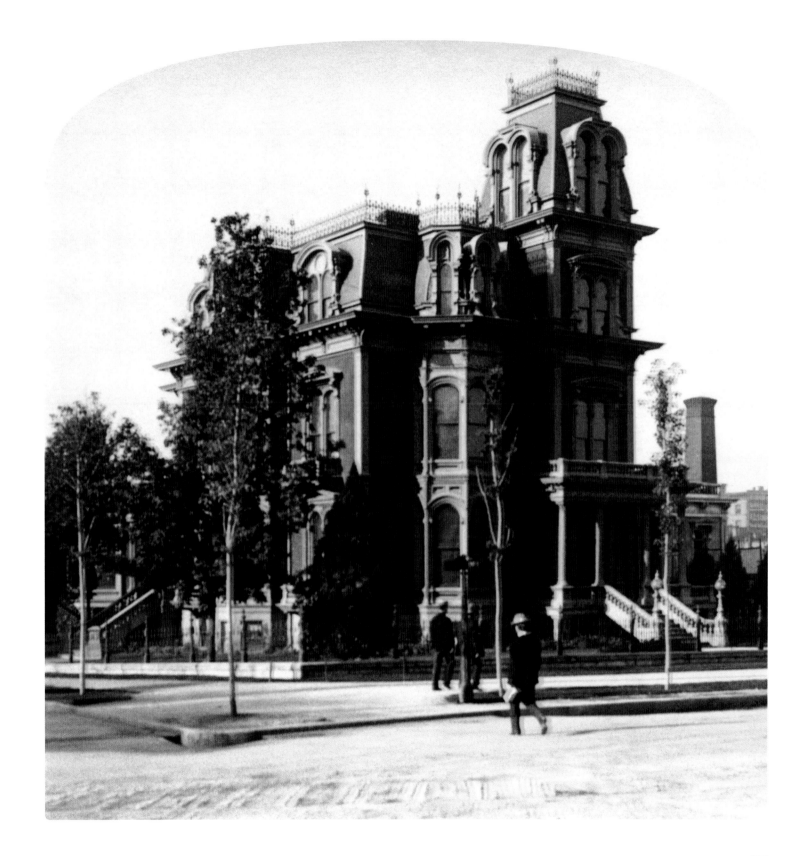

31 Grave of Brigham Young, Salt Lake City, Utah

The Grave of Brigham Young is located in the southeast corner of his private burial grounds on the hillside between South Temple and First street, a little east of the Eagle Gate. The burial site overlooks the city and valley on the south and west, and could be described as a splendid resting place for the great Pioneer after life's troubled dream had passed. According to written instructions to his family, a stone vault was made under the personal superintendency of his son, John W. Young—who in the later years of Brigham Young's life was his counselor in the Mormon Church Presidency. The vault is seven feet eleven inches long, four feet wide, and three feet three inches high. The cut stone of which the vault is made is doweled and bolted with steel and over it is placed a huge granite slab, The whole vault is surmounted, as will be seen in the stereograph, with an iron picket railing. Thousands annually visit this spot, some out of idle curiosity, but many out of sincere respect to the memory of the great Pioneer. President Young died on the 29th of August, 1877. His interment took place on the 2nd of September. While his remains lay in state in the great Tabernacle, it is estimated that 75,000 people passed the bier, each one halting for a moment to look upon the features of the great leader. "In every quarter of the globe," says a great historian [Hubert Howe Bancroft], "the death of Brigham Young excited more remarks than would that of a great monarch."

The grave remains in an unobtrusive spot in the avenues north of Temple Square, tucked away behind a shady residential street. Half a dozen of Young's family are buried alongside him.

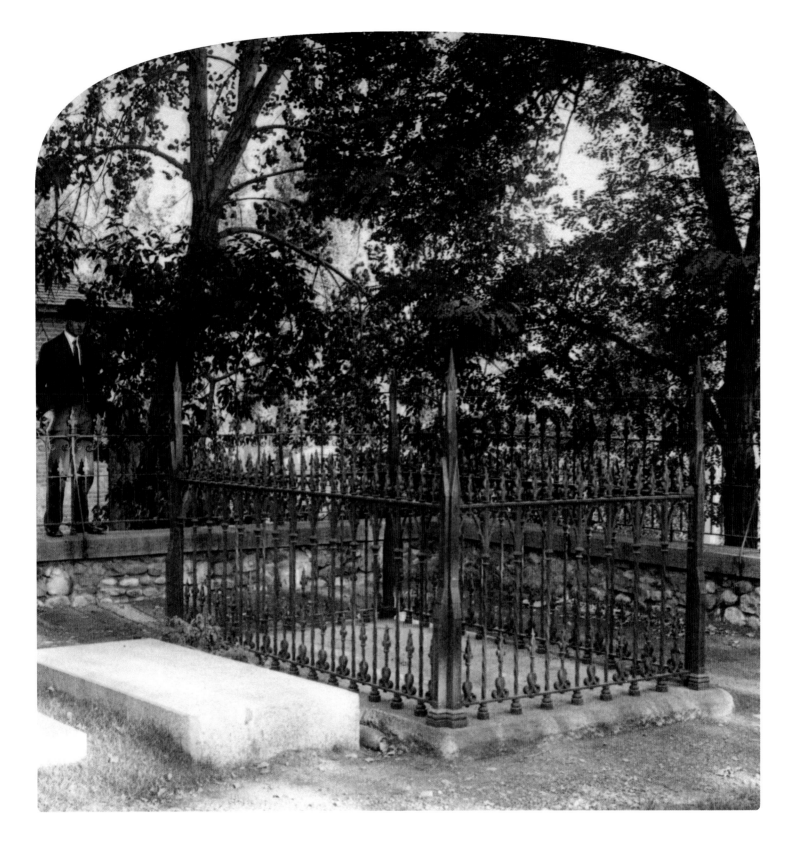

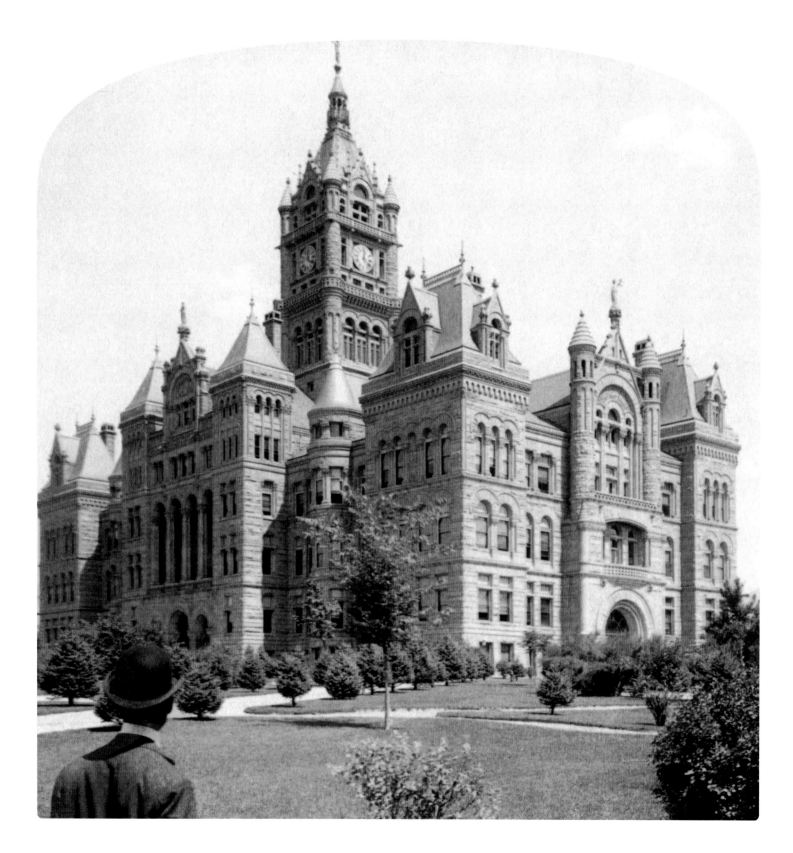

32 Court House—City and County Building—height 256 feet, cost $800,000, Salt Lake City, Utah

The City and County Building stands on one of the ten-acre blocks of Salt Lake City, between Second East and Fourth and Fifth South streets. The block was formerly known as "Emigration Square" for the reason that it was the old camping ground of emigrant trains coming in from the plains through Emigration canyon on the east side of the Salt Lake valley. The building is what is called the Romanesque style of architecture. It is 272 feet in length, by 156 feet wide, and is four stories in height. The central tower, however, rises to the height of 250 feet, and is surmounted by a bronze figure representing Columbia. The material of which it is built is called "kyune" [sand]stone, of a light grey color, and is produced from Utah quarries [south of Kyune Pass near Price]. The building is fire-proof and cost upwards of $800,000. The offices of the Salt Lake City and County government conjointly occupy the building; and it was erected conjointly by those civic divisions. The grounds are beautifully laid out in walks, lawns and shrubbery, and at night are beautifully illuminated by electricity.

This was also the state capitol from 1896 until the present capitol was completed in 1915.

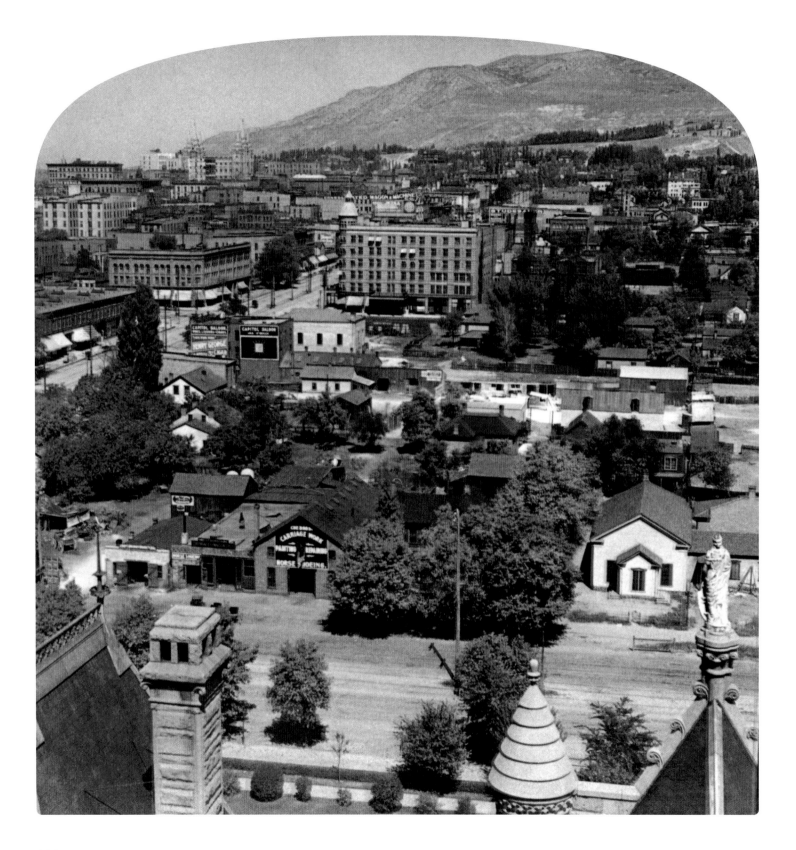

33

Salt Lake City, northwest from the Court House—the Temple at distance left—Utah

This view shows the northern section of Salt Lake City from the tower of the City and County Building. It overlooks the heart of the business section of the city. In the distance on the left is seen the Mormon Temple, and beyond, the spur of mountain which here runs down some distance from the Wasatch range into Salt Lake valley.

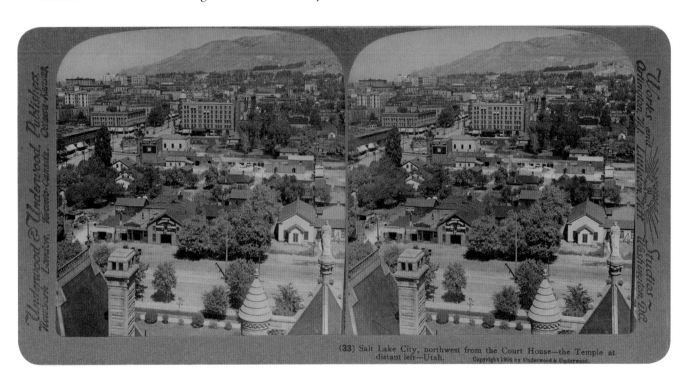

(33) Salt Lake City, northwest from the Court House—the Temple at distant left—Utah. Copyright 1904 by Underwood & Underwood.

34 Looking southeast along Main street, Salt Lake City, Utah.

This stereograph gives another view of the central business district of Salt Lake City. We are looking south on Main street, which has quite a metropolitan air. The volume of business transacted in this queen city of the intermountain region may be, to some extent, understood from the following statement concerning the bank capitalization, resources and deposits: "The total capitalization of the banks of the State amount to $4,407,893; the total resources equal $59,311,567; the commercial deposits aggregate $27,032,721; their savings deposits amount to $7,702,835; while they have a surplus and undivided profits amounting to $13,491,285."

The quotation is from George E. Blair and Robert W. Sloan, *The Mountain Empire: Utah*, 1904. The view of downtown traffic was taken from a porch roof where today the City Creek Plaza skybridge crosses the street. In addition to the trolley, foot traffic, and horses and wagons, notice the primitive open-air automobile crossing the intersection.

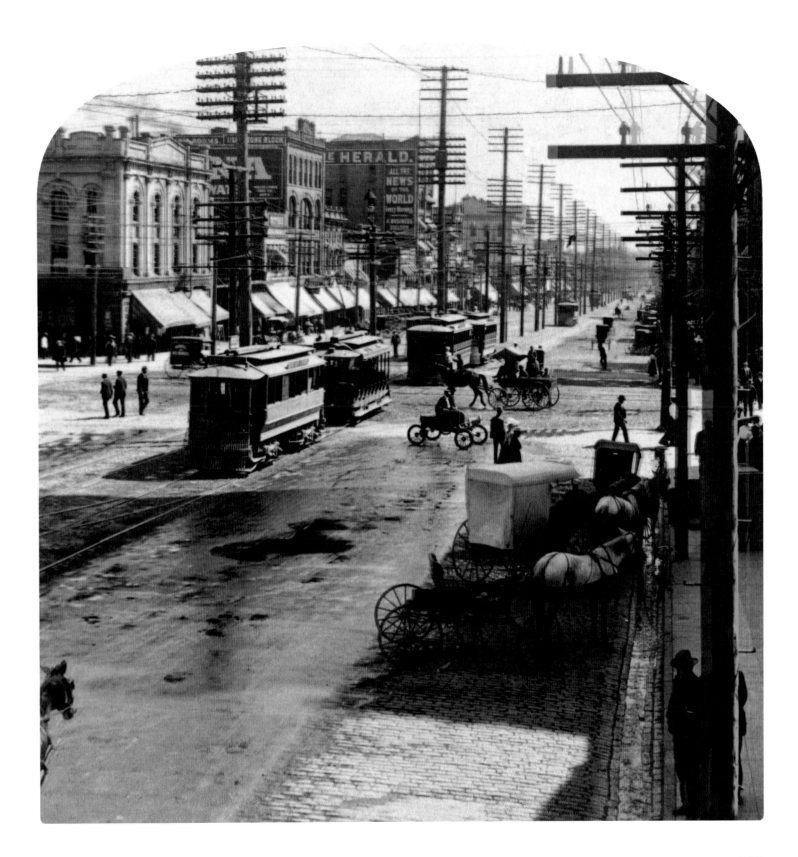

35 Great Pavilion at Saltair Beach, Salt Lake, thirteen miles due west from Salt Lake City, Utah

The Saltair Bathing Pavilion, the east side of which is shown in stereograph 35, is thirteen miles directly west of Salt Lake City. The building is Moorish in its style of architecture, and with the attendant bathing houses cost $250,000. The total length of the buildings from east to west is 1,115 feet and the greatest width is 335 feet. The height from the water to the top of the tower is 125 feet. It has two main floors, the lower one, used chiefly for lunching and picnic purposes, is 151 by 253 feet. The upper floor, used chiefly for dancing, is 140 by 250 feet. No pillar or other obstruction is found in this magnificent dancing pavilion, the roof being dome-shaped, patterned after the roofing of the Mormon Tabernacle in the Temple square, and, in fact, is of the same size, but the frame work of the pavilion is of iron, while that of the Tabernacle is of wood. There are 600 bath [fresh-water shower and dressing] rooms; and at night, during the bathing season, the whole pavilion is lighted by 1,250 incandescent, and forty arc electric lights, which give this chief Utah pleasure summer resort the air of fairyland. The building was commenced February 1, 1893, and was opened the following summer to the bathers and pleasure seekers.

For another two years, the LDS Church would own the Saltair resort. After burning to the ground in 1925, a new pavilion would be constructed at the same site. In 1958 it closed, was abandoned for many years, and burned down again in 1970. Another incarnation appeared in 1981 about a mile west of the original resort.

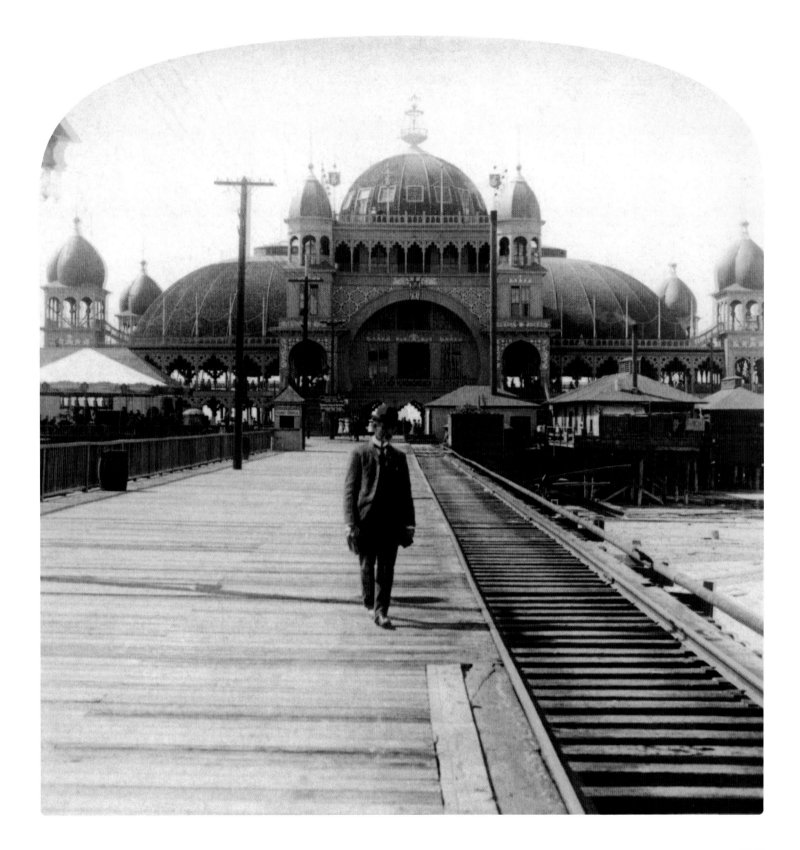

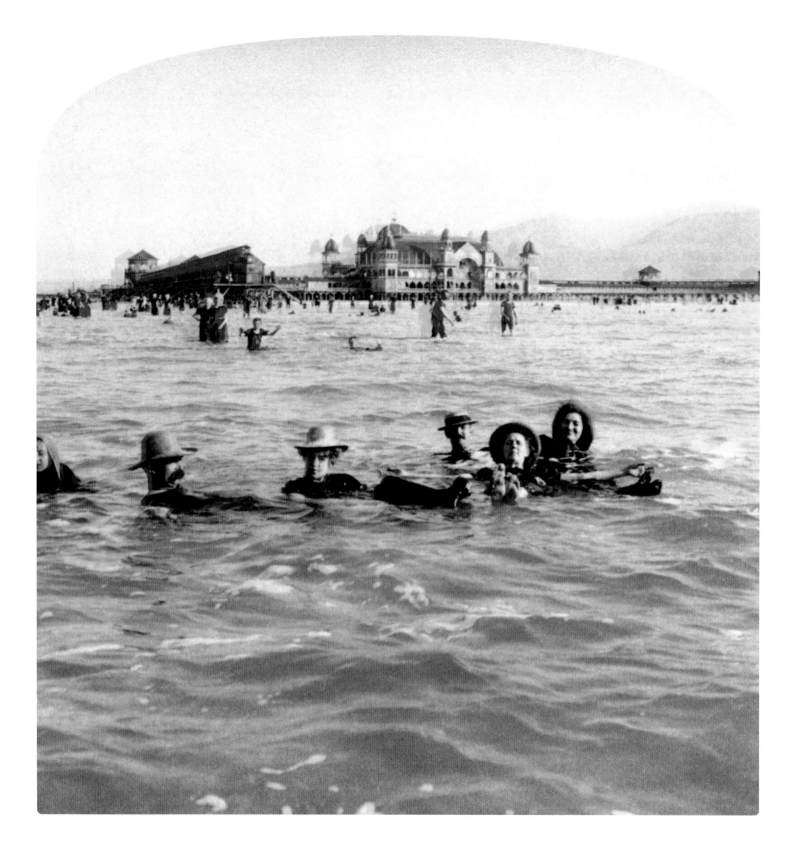

A 3-D TOUR OF LATTER-DAY SAINT HISTORY

36 Great Salt Lake and the Pavilion—Bathing scene, showing density of water in Great Salt Lake

In this view we are looking from the northwest towards the Saltair bathing pavilion; and the scene is a typical one in the heart of the bathing season. In the foreground is really an exhibition of the buoyancy of the waters. A person may extend himself at full length on the surface of the water, and with the slightest ease balance himself in comfort. Bathing in the lake with the subsequent shower bath of fresh water, with which each of the 600 bath rooms is supplied, is refreshing and a rare privilege for people inhabiting an inland country. The comparative density of the lake water is seen in the following table:

	Water	Solids
Great Salt Lake	74.78	25.22
Dead Sea	76.0	24.0
Mediterranean Sea	96.2	3.8
Atlantic ocean	96.5	3.5

Dr. James E. Talmage, of the State University, speaking of animal life in the lake, says:

> Of animals but few specimens have been found in the lake, but these few are represented by swarming numbers. Among the animal forms already reported as common to the lake, the writer has confirmed the presence of four: (1) Artemia fertilis, Verrill [brine shrimp]; (2) the larvae of one of the Tipulidae, probably Chironomus, Packard [midges]; (3) a species of Corixa, probably Corixa tricolor, Uhler [aquatic bugs]; (4) larvae and pupae of a fly, Ephydra gracilis, Packard [brine flies].

The lake, it is said, is eighty miles long by fifty wide, and is deepest on the west side, the greatest known depth being sixty feet. In the vicinity of the Saltair Pavilion are extensive salt works. During the high water season extensive artificial ponds are formed which by evaporation are converted into salt beds, which later are thrown into huge truncated pyramid forms, and later the crystal material is shipped to the refining works, and also to the smelters of Utah, Idaho, Montana and Colorado, for fluxing purposes. Salt Lake is rapidly giving to Utah the popular and poetic name of the "Dead Sea State"

Heber M. Wells has the distinction of being the first governor of the State of Utah. Utah was admitted into the sisterhood of states by the proclamation of President Grover Cleveland, on Saturday, the 4th day of January, 1896, and the State officers were installed on the Monday following, January 6th. A full set of State officers had been elected in the November previous, 1895. The first term was fixed at five years, and the succeeding terms at four years. After five years of service in the capacity of chief executive of the State, Governor Wells was renominated by his party and elected by the people for a term of four years, so that for nine years the gentleman has served as governor of the state, and has given quite general satisfaction in discharging the duties of his high office, especially in the social functions of the office which naturally fall to the chief executive of the State. He bears an honored family name; for among the pioneers of Utah there is no man that was more highly esteemed by the people than Daniel H. Wells, the father of Governor Wells. He was recognized as one of the wisest legislators in the early history of Utah and his political foresight and judgment had much to do with forming the policy followed by the Mormon Church leaders, and it is undoubtedly the case that Governor Wells owes much of his success politically to the honored name of his father. Governor Wells was born in Salt Lake City, August 11, 1859.

Wells was elected in 1895 and served until 1905. He died in March 1938.

38 President Joseph F. Smith, left, Second Counselor Anthon H. Lund, center, First Counselor John R. Winder, right

This view of the three men who at present constitute the First Presidency of the Mormon Church is taken in their office on East South Temple street, in the group of buildings between the Bee Hive House and the Lion House. It shows them sitting at their council-table where the many sided interests of the Church are considered daily and disposed of. The Mormon Church in her polity is not confined merely to abstract questions of theology, or the probable future state of man. It has something to say concerning the present welfare of man, and has instructions and counsel to give to its large membership upon their personal relationship with each other, as well as upon their future spiritual welfare. It has colonization enterprises to consider; business interests to manage, and a large revenue to dispose of in charities, as also in the building of temples, in the building of ordinary places of worship, in the interests of Church educational institutions, of which it has a large number. It has to consider the interests of its missionary enterprises, extending into nearly all the nations of the earth and among Polynesian peoples. All this work, both domestic and foreign, temporal and spiritual, is under the immediate management and executive control of the First Presidency of the Church, who are in daily council and constant consideration of these various interests. It is a matter of pride with the Mormon people that each of the Church Presidencies—of which, counting the present, there have been six—have had the entire confidence of the membership of the Church, and that that confidence has not been abused. All down the line the presidents have been men who have labored with singular disinterestedness for the welfare of the Church and the progress of its work. This is true of all the Presidencies that have existed, but of no one of them is it more especially true than of the one now at the head of the Church.

The personnel of the present First Presidency is interesting. The President, Joseph F. Smith,—seated on the left in the stereograph—was born at Far West, Missouri, on the 13th of November, 1838, in the midst of the most violent persecution through which the Church has ever passed. His childhood was spent amid the exciting scenes attendant upon the persecution of the Saints at Nauvoo, ending in the martyrdom of his father and uncle and the expulsion of the Saints

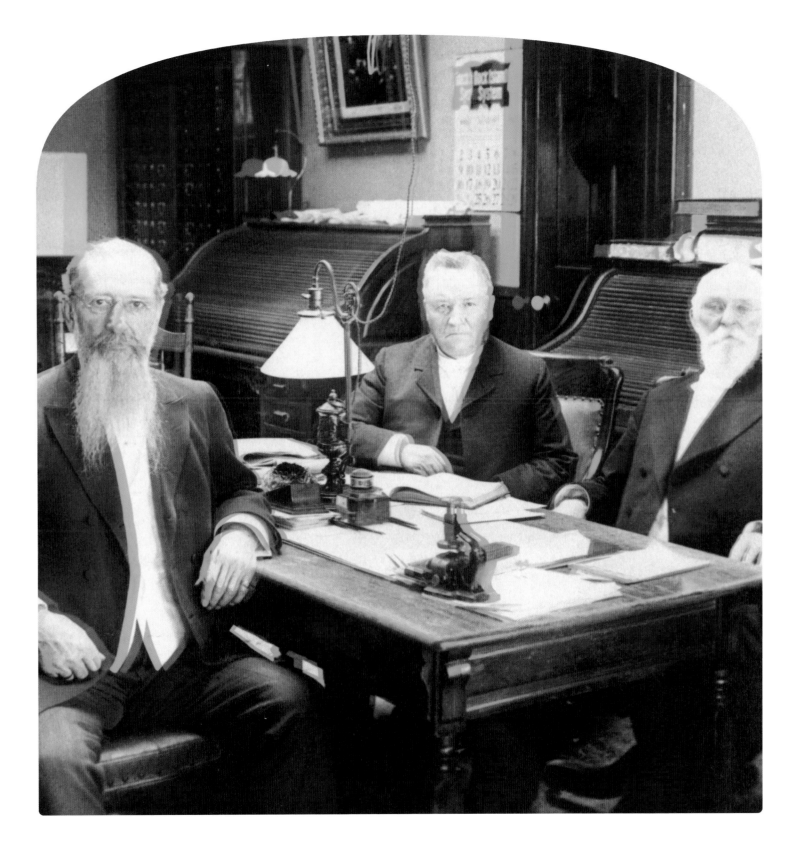

from their homes in that state. His youth was spent in the pioneer life of the people in Utah, and his early manhood in the performance of missionary labors in the islands of the Pacific, in the United States, and Europe. For fourteen years he was a member of the Council of Apostle[s]—1866–1880. For seven consecutive terms he was a member of the Utah Territorial Legislature. The more mature years of his life have been spent in the Presidency of the Church, having been the counselor to the late Presidents John Taylor, Wilford Woodruff, and Lorenzo Snow. So that through all the years of his life he has been most closely connected with the Church and its constantly increasing interests.

President Smith is the son of Hyrum Smith and Mary Fielding. Hyrum Smith, it will be remembered, was an elder brother of the Prophet Joseph, and was killed with him in Carthage prison; so that President Joseph F. Smith is a nephew of the earthly founder of Mormonism, and a descendant of one of its greatest leaders. So central and commanding was the figure of the Prophet Joseph in Mormonism that nearly all other characters of the early days are overshadowed by him, and this circumstance has led many to overlook the real greatness of Hyrum Smith, and the importance of his relationship to the work of God in the last days. But Hyrum Smith was really a great and estimable man. His was one of those steadfast natures whose high zeal knows no abatement, and who is capable of living on high plains of thought and feeling. If they do not rise to the highest summits, neither do they sink into the lowest valleys, but move forward on what we may call a high plateau of intellect, feeling and living. He was a counselor and friend such as the prophet needed. The nature of the one was an excellent supplement to that of the other. Their natures and their lives coalesced until they were well-nigh as one and inseparable. Of his brother Hyrum the Prophet once said: "I could pray in my heart that all my brethren were like unto my beloved brother Hyrum, who possesses the meekness of a lamb, and the integrity of a Job; and, in short, the meekness and humility of Christ; and I love him with that love that is stronger than death, for I never had occasion to rebuke him, nor he me." The friendship subsisting between these two brothers, Joseph and Hyrum Smith, is one of the most beautiful things in the history of Mormonism, and sanctified as it was by the martyrdom of both, it deserves to be chronicled as one of the historical friendships of the world. It is deservedly said of them, "In life they were not divided, and in death they were not separated."

In President Joseph F. Smith the Saints of today see reflected many of the high qualities of his sainted father, united with executive abilities which

perhaps were not so marked in Hyrum Smith. He lives in the affections of his people, because of the uprightness of his life, and the general honesty, integrity and courage of his soul. He is bound to them by every possible tie that can bind a leader to his people. They believe in him absolutely, trust him implicitly, and will follow him, perhaps, as they would follow no other man now living. With such a leader and such a following, Mormonism during his administration will doubtless develop the highest and best things of which it is capable.

President Smith's first counselor, John R. Winder, seated on the right in the stereograph, was born in Biddenden, Kent, England, December 11, 1820. President Winder is a man of affairs and brings to his work an alertness that is little short of the marvelous. He accepted the gospel in England under the ministration of Elders Orson Spencer and Orson Pratt, in 1848. Five years later he emigrated to Utah, where he arrived in October, 1853. From that time until the present he has been identified with all the developing interests of the people of the intermountain west; and now with the frosts of eighty-four winters upon his head, he is still actively alert in all that concerns them. His nature is a never failing source of cheerfulness and hope that knows no bounds, and he brings to the consideration of all the many interests of the Church the hived wisdom of an extensive experience. If the general principle is true—and no one questions it—that in the midst of counsel there is safety, then doubly is it true of the counsels of such men as John R. Winder.

Anthon H. Lund, President Smith's second counselor—the central figure in the stereograph—is of Scandinavian nationality, being born in Aalborg, Denmark, on the 15th of May, 1844. While a man of sound judgment in general business affairs, President Lund is perhaps the most scholarly man in the Mormon Church. His early education was carefully provided for. He is well up in the classical and modern languages. He is widely read, and a man of sound literary judgment. His character is strong but his manner gentle; and his influence, perhaps, is more widely felt on that account. He is profoundly versed in the principles of his religion, and no one can converse with him upon the subject of his faith without becoming impressed with the absolute sincerity of the man, though his native modesty always restrains him from every appearance of aggressiveness in the presentation of his views to others. It will readily be observed by the reader, that if my brief analysis of his character be correct, he is admirably suited for the position he holds as Counselor to President Smith, and the Historian of the Church.

CONCLUSION

We have now completed the tour through the stereographs from Palmyra to Salt Lake City; and the reader has before him in outline the rise and progress, up to date, of the Mormon Church. Anyone who follows its story through these stereographs and considers what they reveal of its growth and development must be especially impressed with one fact, viz.: the steady growth of this thing called Mormonism. It is evident that so far it has overcome all the obstacles that have confronted it. It has successfully lived down every opposition. Every effort of its enemies has but resulted in its enlargement. Not the martyrdom of its earthly founder; not its enforced exodus from the borders of civilization to the wilderness; not the death of its great pioneer leaders; not the advent of railroads and telegraph lines bringing it in contact with the spirit of modern civilization— none of these things seem to affect it in the way of working its destruction. Its prospects are brighter today than ever before. Its faith is more intelligently conceived by its following, and therefore is it more strongly fixed in their hearts. Its own educational institutions are giving better form to its system of theological doctrines. It is rapidly forming a body of literature that must in the end influence the religious ideas of millions of people yet unborn. The sober-minded are ready to concede that as the past is filled with triumphs for this modern faith, so is the future pregnant with possibilities for it; and the end thereof no merely human wisdom may prophesy.

APPENDIXES

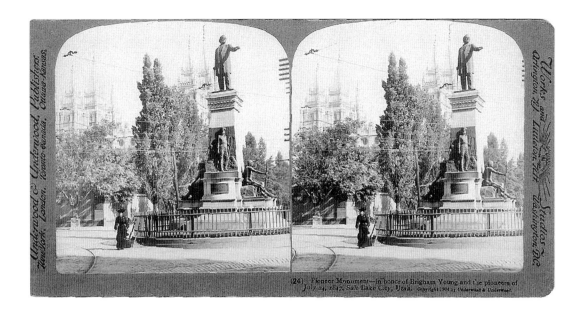

ALTERNATE VIEWS

In 1904 travel to remote places was difficult and expensive. Once a site had been selected, twin images were exposed on heavy plates of emulsion-coated glass, developed, and washed. The resulting negatives were used to make contact prints that were pasted onto cardboard to create the stereographs.

Whenever possible, multiple exposures were made at each location to provide replacements in case the original plates became broken or damaged. And while on the site,

the photographer would usually experiment with variations on a theme. For instance, the above picture of a woman near the Brigham Young Monument is a bit more reverent than the more interesting version shown on page 85.

As another example, when it was discovered that John Taylor's home was not pictured correctly in the 1904 stereographs (page 59), a negative that showed the Nauvoo printing complex was substituted the next year when it was discovered that it included Taylor's actual home.

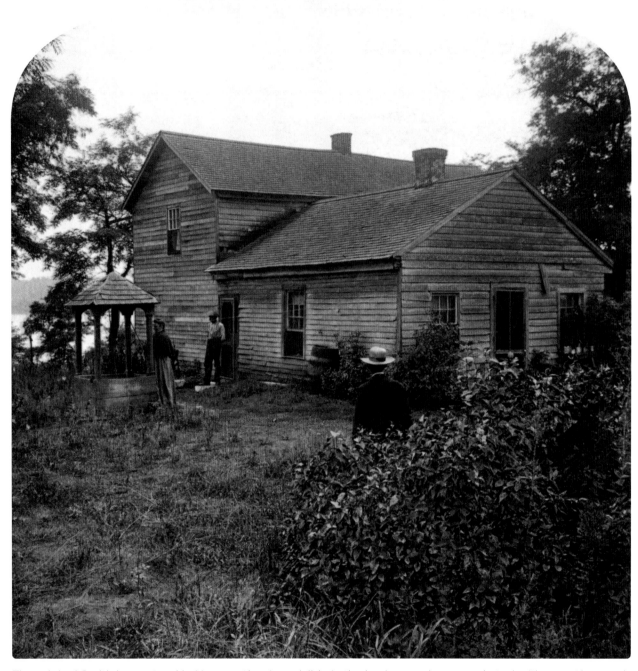

The original Smith homestead in Nauvoo, the river visible in the background, was marketed with a caption reading, "6. The home of the Prophet, Joseph Smith—looking southwest across the Mississippi river—Nauvoo, Illinois." It was probably part of another Underwood & Underwood tour involving scenes from the Mississippi River or some related topic. The Joseph Smith home was included in the picture of Emma Smith's grave, image no. 13, in *The Latter-day Saints Tour*. See LDS Church History Library, PH 4325, online at history.lds.org/section/library.

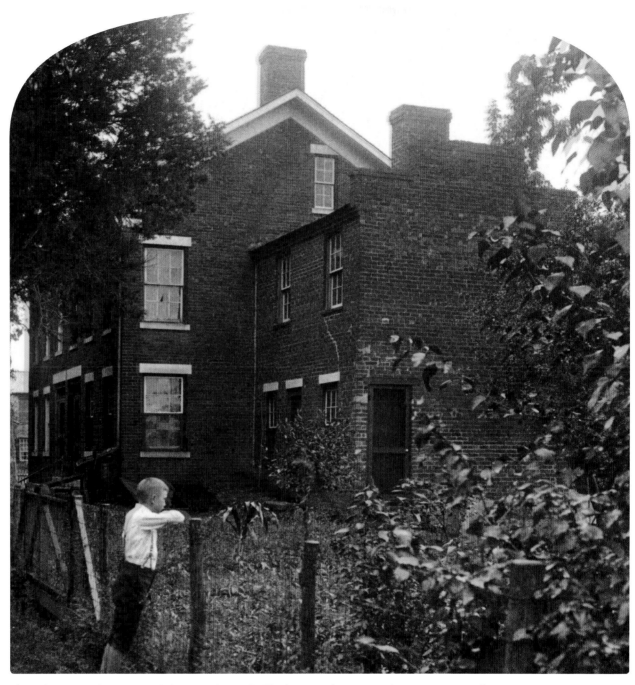

This alternate view carried the caption, "13. The home of Lorenzo Snow, Nauvoo, Illinois." Image no. 11 in *The Latter-day Saints' Tour* showed a different house, or perhaps the front of this structure. Ironically, neither seems to have been Lorenzo Snow's house.

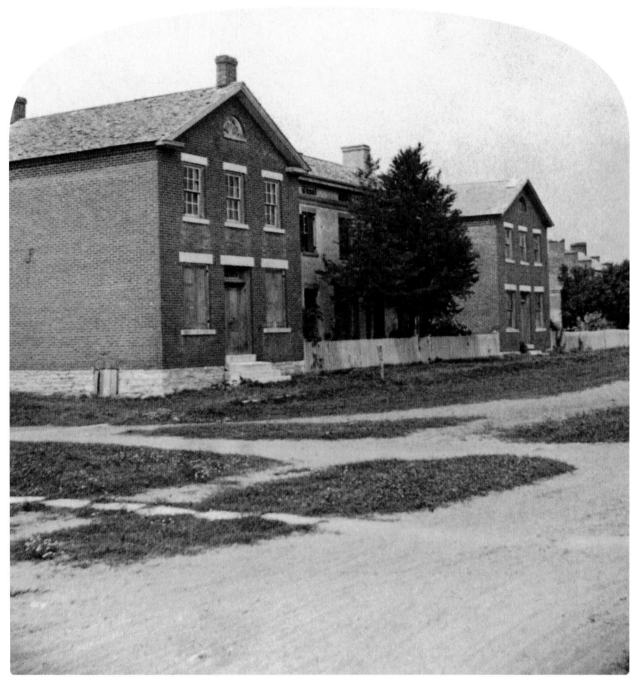

Even if John Taylor wanted to put distance between himself and work at night, his house was so close to the printing press where he was the editor, it barely fit between the press and the post office on the other side. Beyond the *Times and Seasons* building is the Stoddard tin shop that appeared in the 1904 collection of stereographs, misidentified as Taylor's home. It was just two doors away.

MAPS AND AERIAL VIEWS

The stereoscope was probably one of the first optical entertainment devices to find its way into people's lives, and provided a way that anyone looking into it could be mentally transported to places hundreds and thousands of miles away. Today the latest similar trend would be virtual reality goggles, incorporating an electronic viewing screen that allows participants to immerse themselves into a scene and gaze in all directions as though they were really there.

The theme of this book is what LDS history sites looked like in 1904 and their role in Mormon history. Limited by what the photographer chose to aim his camera at, a good example is Lyman Wight's cabin in the valley of Adam–ondi–Ahman on page 36. We can clearly see that the cabin is a remnant of earlier days. However, it is a poor substitute for being able to explore the entire valley.

The following pages contain a few maps of various kinds to orient readers regarding the places John Califf selected to be stereographed. However, the maps we have chosen show these sites in ways neither Califf nor Roberts would have thought possible.

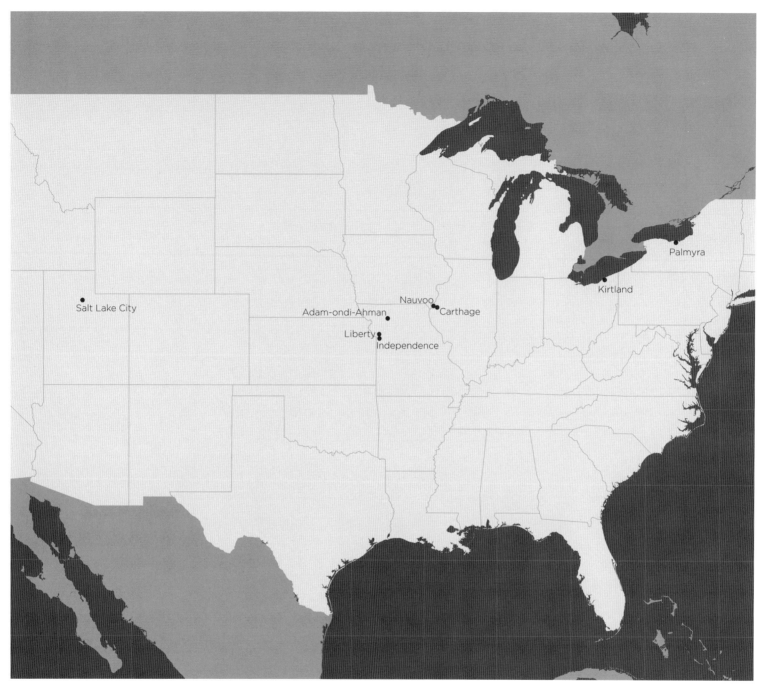

Salt Lake City

Adam-ondi-Ahman

Liberty
Independence

Nauvoo
Carthage

Kirtland

Palmyra

Joseph Smith was born in Vermont and raised in upstate New York. In 1831 when he was twenty-five, he and his followers moved to what was then the western edge of the settled part of the continent, on the southern shore of Lake Erie. But almost immediately, some of them began pushing farther west, this time to the far side of Missouri where life was more primitive still. They then back-tracked 250 miles to Illinois and spent seven years building the city of Nauvoo. When it came time to abandon Illinois and trek to the Rocky Mountains, the distance from Nauvoo to what became Salt Lake City was 1,300 miles (2,000 kilometers).

The town of Palmyra, New York, was fifteen miles south of Lake Ontario, situated on an important east–west turnpike and, after 1822, the famous Erie Canal. It had a population hovering around 3,000. This topographic map was prepared by the US Geological Survey about the same time as *The Latter-day Saint's Tour*, the upper left and lower right quadrangles completed between 1900 and 1903 and the other two sections in 1902. Notice that they labeled what is now called the Hill Cumorah "Mormon Hill." It is hard to see, but we added the location of the Smith farm at the jog in the border of Wayne and Ontario Counties. This type of early cartography is available online at *USGS Historical Topographic Map Explorer*, historicalmaps.arcgis.com/usgs.

It was the religious environment that drew Latter-day Saints to Kirtland, Ohio, although the fact that it was a stopover on Chillicothe Road, running from Painesville on Lake Erie to beyond the city of Columbus to the south, made the location a providential choice. This recent view showing the heavily wooded environment gives an idea of how rich in natural resources the area was in the 1830s. The 3-D effect was achieved by combining two oblique views from Google Earth Pro using Japanese photographer/programmer Masuji Suto's freeware program Stereo Photo Maker.

Much like the Temple Mount in Jerusalem, the Temple Lot in Independence, Missouri (the grassy area near the center of the photo), is contested by the Church of Christ–Temple Lot, its chapel on the northeasternmost edge of the property; the Community of Christ (clockwise) with its imposing temple to the east; and the LDS Church (continuing clockwise) with its large visitor center south of that. One can see the domed roof of the Community of Christ's Auditorium to the south and the Old Stone Church across the street to the north from the Church of Christ–Temple Lot. Other churches with an interest in the property include the nearby Church of Christ with the Elijah Message, Church of Jesus Christ–Zion's Branch, Remnant Church of Jesus Christ, and the Restoration Church of Jesus Christ. This image was created in the same manner as the one on page 126.

In a remote corner of northwestern Missouri, Adam-ondi-Ahman (so named by Joseph Smith) is where the church founder said Adam and Eve had lived after they were cast out of the Garden of Eden. Two miles east of the thumb-shaped curve of Grand River, right before it continues east, is where Joseph Smith encountered a cairn he said was an ancient altar. The map is in anaglyphic 3-D, combining a 2012 National Agricultural Imagery Program orthophoto with a 1-meter Lidar elevation model, both available online at the *Missouri Spatial Data Information Service*, msdis.missouri.edu.

Nauvoo, Illinois, was located fifteen miles north of the Des Moines Rapids where the Des Moines River merged with the Mississippi. Ferries had to haul their goods overland to the other side, the first location where that was necessary in the 850-mile stretch from New Orleans. The map is a detail of the 1936 Fort Madison USGS quadrangle. Fort Madison is ten miles upriver on the west side of the river.

The interesting thing about Sanborn fire insurance maps was that they gave the footprint and name of each structure on every street. In this 1898 Salt Lake City map, we see Temple Square bordered on the south by what had been Brigham Street (South Temple), with a note indicating where the temple's "dynamo room" (electrical generator) was located. On the block south of that are the Elias Morris Marble Works, a museum ("Hall of Relics"), a bakery, and other shops. To the right of Temple Square is a smattering of buildings surrounded by stockyards. South of that, the Templeton Building contains everything from a printing press to barber shop, and next door to the east is the ZCMI shoe and overall factory. Sanborn maps are available online, for instance at the University of Utah's J. Willard Marriott Digital Library, collections.lib.utah.edu.

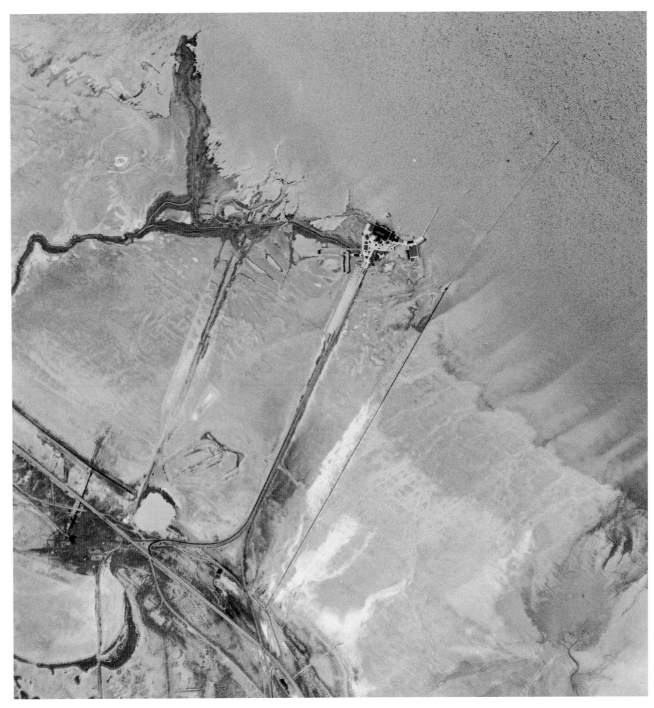

In this 1953 aerial view of the second of four incarnations of Saltair, one can see where the original resort was located on the east–west railway line and the new stretch of track extending north to where the water had receded. The photo is from the US Geological Survey's *Earth Explorer* site at earthexplorer.usgs.gov.

ABOUT THE AUTHOR

Brigham H. Roberts was one of the seven presidents of the LDS First Council of Seventy when asked to write his descriptive narrative for the stereographs in this book. He also served as Assistant Church Historian and was thus eminently qualified. He was the author of nine books. He would later complete the official seven-volume *History of the Church of Jesus Christ of Latter-day Saints*; six-volume *Comprehensive History of the Church*; five-volume *Seventy's Course in Theology*; three-volume *New Witnesses for God*; and two-volume *Defense of the Faith and the Saints*; as well as of another five single volumes and five works that would be published posthumously, including *The Truth, the Way, the Life* and *Studies of the Book of Mormon*. Roberts's logic and prose were impressive, and he was a memorable public speaker. His personal life was multi-faceted: he was a polygamist, politician, opponent of women's suffrage, a trained blacksmith but college graduate, magazine editor, missionary and mission president, and workaholic who was fiercely independent and sometimes stubborn.

ABOUT THE EDITORS

Steven L. Richardson is a BYU graduate, life-long 3-D enthusiast, and veteran map maker of thirty-six years. After retiring as a geotechnical analyst, he began his own cartography company, 2i3D Stereo Imaging, where he applies computer-graphic programming to 3-D map making, as assisted by his son, Benjamin M. Richardson. Previous works include their *3D Atlas of the Salt Lake Valley's Tri-Canyon Area* and *3D Atlas of Zion National Park*.

MORE FROM SIGNATURE BOOKS

The Autobiography of B. H. Roberts
Gary James Bergera, ed.

Glorious in Persecution: Joseph Smith,
American Prophet, 1839–1844
Martha Bradley-Evans

The House of the Lord: A Study of Holy
Sanctuaries Ancient and Modern
Harvard S. Heath, editor of the annotated
reprint of James E. Talmage's 1912 work

Natural Born Seer: Joseph Smith,
American Prophet, 1805–1830
Richard Van Wagoner

The Nauvoo City and High Council Minutes
John S. Dinger, ed.

Red Stockings and Out-of-
Towners: Sports in Utah
Stanford J. Layton, ed.

Salt: Poems by Susan Elizabeth Howe

MORE THREE-DIMENSIONAL FUN FROM
STEVEN L. AND BENJAMIN M. RICHARDSON

An 86-page wire bound book
3D Atlas of Zion National Park

A 48-page wire bound book
Wasatch 3D Atlas

And posters from the 2i3D Company

Desolation Wilderness, CA
Yosemite Valley, CA
Mt. Washington, NH
Bingham Canyon Mine, UT

Cloud Rim, UT
Ghost of Mt. St. Helens, WA
Grand Tetons, WY
Jackson Hole Resort, WY

See more at www.2i3d.com

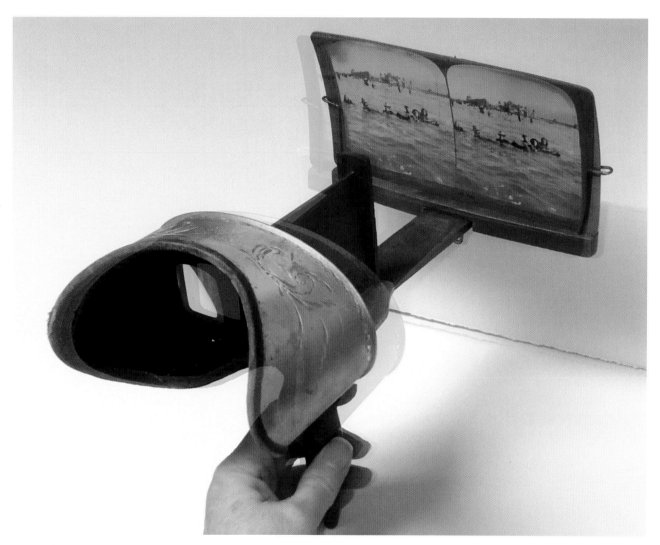

An Underwood & Underwood stereoscope and image of swimmers in the Great Salt Lake from the artifact collection at the Pioneer Memorial Museum in Salt Lake City, operated by the Daughters of Utah Pioneers.

A B C D E F G H I J K L M
N O P Q R S T U V W X Y Z

A B C D E F G H I J K L M
N O P Q R S T U V W X Y Z

The titles and captions of *A 3-D Tour of Latter-day Saint History* are set in Gotham, a contemporary typeface designed for *GQ* by Tobias Frere-Jones and Jonathan Hoefler in 2000. The geometric type was inspired by the lettering on the Port Authority Bus Terminal in New York City with the sensibility of an engineer over that of a type designer.

Garamond Premier, another typeface used in this book, is a new take on a sixteenth-century font. Robert Slimbach released the new font family in 2005 after working on it for over ten years.

The 3-D viewers included with this book were designed with elements reminiscent of the Underwood stereoscope, complete with a handle.